W&W
5.75

SEARCHING FOR ICONS
IN RUSSIA

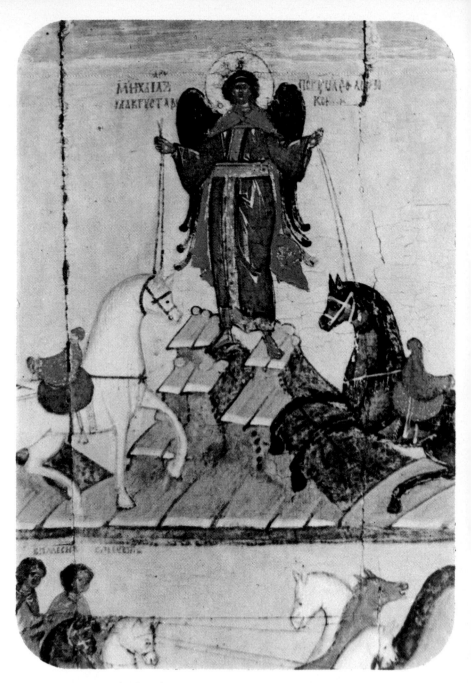

Detail of an icon of Sts Florus and Laurus, 16th century

Vladimir Soloukhin

SEARCHING FOR ICONS
IN RUSSIA

Translated from the Russian by
P. S. FALLA

Harvill Press, London

ISBN 00 272109 00

Made and Printed in Great Britain by
Richard Clay (The Chaucer Press), Ltd.,
Bungay, Suffolk
for the Publishers Harvill Press Limited
30A Pavilion Road, London SW1

Illustrations

1

So you've never collected anything at all? In that case you'll find it hard to understand why I write with such enthusiasm about things which may not strike you as deserving the slightest interest.

For if anyone can truly be called a fanatic in this world, it is not the fisherman who can sit outdoors for ten hours on end in an icy January, or the hunter who doesn't mind crawling about in the marshes for whole days – no, the collector beats both of them.

When two small boys run after you demanding to have a look at your matchbox it is no more than a game – a temporary diversion which may give place to an interest in goldfish, football or the acquisition of books, or simply lapse into oblivion. But when a venerable grey-haired professor begs you in a tremulous voice to bring home a matchbox from your next trip abroad – when, with a trembling pair of tweezers, he sticks the label into an album containing about eight thousand others, and when he is prepared to buy an unusual label at a price I'd rather not mention – then it is more than just a diversion: it's a kind of disease, or rather a passion.

Stamp-collecting is the most widespread form of collecting in the whole world – philatelists have their own special shops and magazines – and yet, if you think about it, it's perhaps the dullest kind of collecting there is. At the beginning people build up their collections one stamp at a time, lovingly steaming each specimen off the envelope and pasting it into an album. The devoted collector will admire his new acquisition

every day, show it off to his friends and dream about it. But suppose one day you walk into a philatelist's shop or a school stationer's, and find that you can buy a whole collection at one go! It's like a fisherman buying three days' catch at the market, or a hunter buying grouse and capercailzies at the Central Co-operative.

No, in my opinion, buying an album full of stamps like that is the lowest depth of the collector's art, since what is lacking is the very thing that makes collecting worth while, namely the spirit of the chase.

With a man who really has collecting in his blood it doesn't matter what he collects: it may be stamps, locks, corks, pebbles from the seashore, neckties, labels off tins, misprints in newspapers, picture postcards (the poet Glazkov had twenty-four albums of these), old books or coins, French Impressionists or Russian *peredvizhniki* * ('Wanderers'), china or bronze, inkstands or handbells (Anatole France), birds' eggs or engravings, kerosene lamps or tiles, butterflies or birds (Sasha Kuznetsov had eight hundred specimens caught by his own hand), wine-labels or accounts of a given subject (Leonid Leonov has a notebook full of descriptions of Russian bath-houses from various books), tobacco-pipes (Ehrenburg) or cartoons without captions (N. L. Elinson), decorations and medals of all countries or swords and daggers (a fine collection in Sir Walter Scott's home at Abbotsford), birds' feathers or paper money (I mean the kind that has gone out of circulation; there is, of course, a different name for collecting modern notes), book-plates or books, buttons or ceramics, Ottoman powder-flasks or ancient manuscripts, autographs or old gramophone records, fans or walking-sticks (I have seen

* An association of Russian realist painters (1870–1923), known as 'The Wanderers' because exhibitions of their works were held all over the country. It included Vasnetsov, Repin, Levitan, etc.

a huge collection of these in an old English country-house), badges or cigar-cases, cuff-links or African masks – in short, it doesn't matter what the collection is, but the true collector must be first and foremost a hunter, not just a man who buys and sells.

In one respect, indeed, the collector is on a higher level than the ordinary hunter. The hunter's quarry is, as a rule, something of which the earth affords plenty. A collector, on the other hand, may find himself in quest of an extremely rare or even unique object, his whole purpose being to make sure that it ends up in his collection and nowhere else. That is why a collector's life is made up of great joys and great disappointments.

Of course, to collect everything is itself an idea of a kind; so is to collect everything antique. Or again, to collect birds' feathers – starting, for instance, with those of sparrows, pigeons and magpies, and going on to peacocks, humming-birds or birds of paradise and fire-birds while you are about it – is also an idea of a sort, but it is a different kind of collection from those of Princess Tenisheva, Count Uvarov or the great Tretyakov*. All these collectors were guided by a specifically Russian idea which led them, like a true compass, through the ocean of antique and contemporary art, enabling them to fish up from its depths just those pearls and grains of precious substance which would go to make a single harmonious necklace.

I do not mean to suggest by this that the collectors responsible for the Hermitage, which contains paintings of all nations and periods, were poorer in ideas and less deserving of our gratitude than Tretyakov or Tenisheva. All I mean to say is that different kinds of collections may reflect, more or less strongly, different types of ideas, or no ideas at all.

* Moscow merchant (1832–1898), patron of the arts, who founded the Tretyakov Gallery.

What is typical of the collector is a concentrated, penetrating attention to his subject. His whole vision is, as it were, a narrow beam of intense light which does not merely play on the surface of objects but illuminates their depths.

Take for instance my own experience, when still a child, as a collector of birds' eggs. In the past all sorts of birds had been flying around – sparrows, jackdaws, wagtails, pigeons – but I had paid no attention or taken them as a matter of course, not troubling to observe them closely. Then, I forget how, I came into possession of my first wild bird's egg: I think it was brought me by some village boys. It was a tiny, yellowish one with brown spots – a sparrow's egg.

I found a big cardboard box, lined the bottom with cotton-wool, and in the top left-hand corner, where one starts writing on a clean sheet of paper, I placed the tiny brownish egg. This was, so to speak, my letter A: the rest of the alphabet remained to be filled in. I began to think how I might get hold of a starling's egg. My work fell off, I lost my appetite and thought of nothing except how to get a starling's egg. When I acquired one I placed it alongside the brown egg in the cardboard box, in the space for 'B'. From then on starlings ceased to interest me, they became invisible as it were, and my whole attention was concentrated on rooks' nests. Soon I had collected a third egg – a green one with brown spots, much bigger than the other two.

Then the fit was really on me. Looking back to those days, I feel as though I was possessed or in a kind of fever. Each night I feared that something would prevent me from going into the woods to pursue my quest. But morning came, the weather was fine day after day (not that bad weather would have stopped me then) and I spent long hours in the coppices around our home, returning only at nightfall.

In former days I had gone for forest walks too, but I had

wandered about without seeing a single bird's nest. In order to discover something in the forest you must keep a picture of it in your mind – then you will find you develop a kind of second sight, and can pick it out at every turn. That is what happened to me in those days: I walked out thinking of nothing but birds' nests, and lo and behold! I discovered them everywhere, in places I had never noticed before, as if I had just been granted the gift of sight or had put on magic spectacles.

My constant reading at this time was Mikheyev's *Guide to Bird's-nesting*, which I found more interesting than the most thrilling novel. This was the sort of thing it told me: 'Black kite. The hollow of the nest is filled with earth or dung so that it is flat or even convex. The nest is lined with bits of wool, grass or paper together with fragments of rag and decaying food, which give it an unpleasant smell.'

Later, if I had remained an enthusiast, I might have collected the egg of an eagle-owl or, shall we say, a pink flamingo, and a nightingale, and a loon (or whatever they called it), and a swan, and a pelican, and finally that unimaginable trophy, a crane's egg. But why am I talking about birds' eggs when this story is about 'Black Boards'.*

Firstly, because I wanted to show that the passion for collecting is part of human nature, and that it only requires an impulse for it to awaken and take possession of the individual.

Secondly, because I wanted to show that I am one of those in whom this passion is alive.

Thirdly, to show that it may be a passion devoid of any rational idea – what is rational about collecting birds' eggs? – and yet take possession of a human being, as passions do.

Fourthly, one must remember that a man always talks about the object of his passion with a partiality that is meaningless to others, and I must apologise if the reader cannot understand

* The title of the original Russian edition.

my partiality for things that, to an outsider, may appear un-worthy of it.

I am a collector, and that must be my whole excuse. And the best I can wish the reader is that he too should be one, if only for a short time – if only for a year or so!

2

I ONCE visited the studio of a Moscow artist whom I knew, and was astonished to see quantities of icons all over the walls. Some were as big as a cottage window or even a window in a church; others were the size of those you might see on a triangular stand, called a *kiot*, in the 'front corner' of a peasant's hut.

I should mention that even in my most ardent days as a Pioneer, from 1930 to 1937 or thereabouts, I was never a militant destroyer of icons like some of my schoolfellows, who would tear them down from their place of honour in the hut and throw them into the stove as soon as their parents went out of doors. This was a heroic act in a way, as they sometimes got beaten, but at school they were held up as a shining example.

Of course icons can be looked at in two ways, and one's attitude towards them will differ accordingly. On the one hand an icon is an object of piety, a part of religious life, an accompaniment to devotion and ritual; on the other it is a work of art, a painting of historical value and national importance. Confusion between these two points of view has led to the destruction of a vast number of icons – an especially sad loss because it is irreparable. I have heard that at the very beginning of the Revolution, two railway wagons full of old icons were found at Nizhni Novgorod station. When they asked a high official of the district (it was probably still called a *gubernia*) what was to be done with them he replied: 'Icons? What icons? What are they for? Burn the lot!'

There was a similar case at Ryazan not so long ago, on a farm where they wanted a place to store milk-bottles. They found a cellar full of icons belonging, no doubt, to the local museum, and burnt them for the sake of the space.

No doubt both these cases were due to stupidity and want of imagination on the part of officials, but is that the whole story? It's really too complicated a question to decide out of hand – one of these days, in some future book, I shall have a try at answering it.

Of course, when Kievan Russia was converted to Christianity under Prince Vladimir they threw the idol of Perun into the Dnieper – as an object of heathen worship, the first Christians couldn't be expected to allow it to survive. But supposing that gilt wooden statue from a pagan temple had been preserved to this day – what a rarity it would be, what an ethnographical treasure, what a showpiece in the world of Russian antiquities! The gods of the pagan Slavs – Perun, Stribog, Dazhdbog and Yarilo – are so remote from us that it would be absurd today to destroy them as a matter of anti-religious principle, any more than we would destroy works of Greek sculpture because they were worshipped by the ancient Greeks. We are too civilised – or, let us say, we are at least civilised enough not to think of the Venus of Milo as something which deserves immediate destruction because it represents a goddess.

As for myself, while I was not a fervent enemy of icons, I was naturally not a protector of them either. As a Pioneer, why should I have been? The question did not arise in my mind one way or the other. That part of my consciousness – call it brain or soul as you will – which might in theory have reacted to icons and determined my attitude towards them was to all appearances switched-off, frozen, anaesthetised.

Later on I went to the Technical High School, did my army service, became a student at the Literary Institute, travelled on

reporting assignments for *Ogonek** and wrote poems about love and nature, together with articles on sheep-breeding in Kirgizia, bee-keeping in Ryazan, irrigation in the Don valley and the agricultural problems of Nenets tribes in the tundra. I read books, went fishing, picked mushrooms, drank, kissed girls, went to football matches or to films and the theatre, played chess with my friends, visited the Tretyakov Gallery and current exhibitions of painting; I even collected birds' eggs and kept an aquarium, and altogether it seemed to me that my interests were sufficiently wide and varied. No doubt in a sense they were. But the notion of an icon – a Russian icon, an old Russian icon – had no existence for me: I thought no more about it in those days than I do now about – what shall I say? – well, for the sake of argument, the problems of starfish migration in the Kara Sea. I am sure there are starfish in the Kara Sea, and no doubt they have their problems and a man might spend his life studying them and finish up by writing a thesis or two on the subject, but for me these problems don't exist; in fact, I invented them merely as an example and shall soon forget them again.

Just in the same way, the term 'Russian icon' meant nothing to me. The comparison with starfish was perhaps not very well chosen, however, because there are some ideas, facts and problems that every Russian ought to know something about, whatever his role in life. You may be an expert on starfish, fresh-water molluscs, the minerals of the Urals or the properties of rare metals; you may be an engineer, a Party worker, a chemist, a combine operator, a footballer, a man of letters, an electrician, a missile expert, a general or a teacher; but if you are a Russian it is your duty to have heard of Pushkin and Dostoyevsky, the Tale of Igor's Raid, the battle of Kulikovo, the church of the Intercession on the river Nerl, the Tretyakov Gallery,

* A popular illustrated weekly magazine.

Rublev's Old Testament Trinity and the icon of the Virgin of Vladimir.

None the less, I must admit the sad truth: on the day I visited my artist friend in Moscow I was better acquainted with starfish (having trodden on a few on the shores of the Kara Sea) than I was with icons. Consequently my surprise was all the greater when I saw them hanging on the studio walls. They were not arranged in uniform rows as they are on an iconostasis, but were mixed up with ordinary paintings and large photographs, and also other interesting objects such as a wooden ladle or a pretty, antique ribbon that had once decorated a girl's plaits.

I had heard before, but without paying attention, that there were people who collected old icons, and a friend of mine had once told me with excitement that he had seen a fine fifteenth-century specimen in somebody's house. But this was wasted on me, since even in the Tretyakov Gallery I always walked past the icons without looking at them. In short, I had paid no attention whatsoever. Now suddenly I was confronted with icons hung all over the studio walls. My friend's wife took me from one to another, doing her best to explain the special and even unique qualities of each – with about as much success as you would have describing the hues of a summer sunset to a blind or colour-blind man. She would say, for instance:

'This is a fairly late specimen, you can see the date 1787, but it's by an excellent artist. Look how the red colour runs across it from side to side. It starts in the bottom left-hand corner and grows stronger as it spreads across in a faster and faster rhythm, till it reaches its highest intensity in the Saviour's garments.

'Or look at this one – this is the jewel of our collection, from the end of the fifteenth century. Look at the boldness and decision of line, the expressiveness and economy of means. The other one was a feast of colour, but here the whole effect is

achieved by line. Now look from a distance at the red one, as though it was just a splodge of colour. The most fashionable abstractionist would be sick as a cat with envy' (the phrase didn't seem slangy on her lips, it sounded highly appropriate) 'if you showed him a splash of colour as expressive as that. It's only a small icon, but it would decorate a whole large wall in any modern interior.'

We stopped in front of another icon of unusual shape: a narrow horizontal panel, with quarter-length figures of seven sacred personages. The central figure was a full-face one of Christ, and on either side three saints were turned towards him: the picture showed not only their faces but their arms, for which there was not much room as they were crowded close together.

'This is what they call a Deesis,' my hostess explained. 'Usually it consists of several icons, with a saint depicted on each. Notice the full, rich green of the background. The icon was painted in the north of Russia, where the green of the vast forests was the northerners' favourite colour and the one they used most for icons. Even the haloes on this one are not golden, as they would be if it had been painted in Moscow, but a soft, tender green colour.

'Look at the position of the arms too. If you follow the line from left to right across the picture you get a wavy, rhythmic effect, like ducks floating. The whole thing is infused with a sense of softness and entreaty. That is what this type of icon is about.'

'Tell me, what are the large black holes at each end of the panel? Are they from nails?'

'Yes. When we found the icon, it was barring up the door to a belfry.'

'How do you mean?'

'Just that. There was a door, and to prevent anyone getting

in they nailed this to it as a crossbar. But it's nothing to be upset about – the icon was saved by being put to practical use. They must have fastened it to the door when the church was closed, in the early thirties.'

'And what about the other icons? I suppose there were several as good as this?'

'We don't know. The church is empty now, anyway. Only this solitary icon survived, having been used to bar up the belfry door. Why are you so surprised? Look at this one now.'

I looked at a large panel, some twenty by twenty-eight inches, showing Christ riding on an ass. There were buildings and a tall tree to be seen, and the people welcoming Christ were throwing palm-branches and garments under the ass's feet.

'There you are. This is called the "Entry into Jerusalem", but its popular name was "Palm Sunday". It belongs to the series of church festivals. It was pure chance that this one survived. We found it in the house of an old woman at Vologda where we put up for the night: she was using it to cover a tub of salted cucumbers.'

'But why, for heaven's sake? Even I, who know nothing about painting, let alone icons, can see that it's a fine work.'

'Yes, if it had looked as it does now, I dare say it wouldn't have been used as a barrel-lid. But wait till we show you what the icons looked like when they were used to bar up doors or windows in closed churches, or to cover barrels, or when they were simply lying about on the floor somewhere. Take this one here: bring it into the next room and let's put it on the table.'

I took the panel, which was quite a weight, and laid it on the table as I was told. It was a mysterious sight: a completely black, impenetrable, unexpressive piece of wood. Here and there it was peeling in tiny whitish flakes, and in one place it

looked as if a layer of plaster had come off. White, crumbling holes showed where small nails had held the overlay★ in place. Some of the nails were still there, and a scrap of metal, the size of a small coin, was attached to one of them: it was jagged at the edge and twisted upward.

My friend the artist had joined us to take part in the operation that now began. His wife took a small piece of cotton wool, dipped it in sunflower-seed oil which she had poured into a saucer, and rubbed it over the surface of the panel, on which the outlines of a picture began to appear through the deep black. It was as though a dull, dirty, flaking expanse of roofing-iron were being transformed before our eyes into a sheet of glass, still black indeed, but allowing something to be discerned beneath. This in itself seemed to me marvellous.

'Can so much dirt really accumulate in the course of centuries?' I asked, thinking that this might really be so.

'It isn't dirt, it's drying oil.'

'But then why did they cover the picture with it?'

'The oil was to protect the paint from damp, scratches and the effects of time generally. Besides, when the icon was first covered with the oil it would shine and glitter. It was the early equivalent of varnish. But it had one unforeseen defect: in the course of eighty or a hundred years it goes black and, instead of making the painting bright and radiant, it covers it with a sort of dark curtain. What we are going to do now is to cut a hole in that curtain.'

The artist and his wife were now busying themselves with speed but without unnecessary fuss. I could not help being reminded of a surgical operation as they laid the panel on the table, pulled over a bright lamp on a concertina bracket and spread out their instruments: a scalpel, tweezers, a phial containing some

★ Icons were frequently encased in a metal cover or *riza* in which openings were cut to show the essential sections of the painting.

chemical or other, cotton wool and a syringe. And now the two surgeons, or the surgeon and nurse, bent over the patient with concentrated attention.

It was all so new and fascinating that I tried not to miss a single movement. With a pair of scissors the 'nurse' deftly cut out an oblong piece of flannel about half the size of a man's hand: she trimmed the edges to an exact rectangle and, using the tweezers, dipped it into the saucerful of evil-smelling liquid. This must have been corrosive, as she took care not to wet her fingers.

'Where shall we put it?' she asked her husband, as she turned the flannel this way and that so as to get it thoroughly soaked. 'Shall we start with the face?'

'Not on any account.'

'What about the city? Or the sword?'

'No, let's be careful and start with the robe. Here will do. Either I'm much mistaken, or this one will be a beauty.'

I forgot to say that when they rubbed the icon with the sunflower-seed oil we could see on it, through the black, the full-length figure of a saint. In one hand he was holding at shoulder-level something rather like a town or a monastery, or at any rate a conglomeration of buildings, and in the other hand, at the same level, a short, slightly curving sword.

'It's St Nicholas of Mozhaisk,' they explained to me. 'A magnificent theme. In one hand he holds a Russian town and in the other a sword to protect it from destruction or any sort of danger. The common people were very fond of this icon. It's still called "St Nicholas with the Sword and City".'

I realised now that the surgeons were deciding on which part of the icon to lay the piece of flannel steeped in corrosive liquid. The saint's countenance was too important, the 'city' was also too risky, and so they chose the robe. The pale-green flannel, darker now from the liquid, adhered easily and closely

to the centre of the panel. They straightened and smoothed out its edges; Nina (my host's wife) did not risk her clever fingers in this operation, as they laid a piece of glass on the flannel and pressed it down.

'Bring the weight!' said the surgeon-in-charge sharply. An old-fashioned two-pound weight was brought, and they laid it on the glass with the flannel beneath. Then we all straightened up drew breath and stepped back from the table: a few minutes had to elapse for the chemical under the glass to do its work.

I did not intend to waste those minutes: I began asking questions, and although they were very naïve ones my hosts answered willingly, explaining everything as if to a child. Thus I learnt that the icon-painters began by fastening a coarse canvas to the panel and then applied to it a foundation of white gesso, usually composed of alabaster and glue. This, when dry, was polished and resembled smooth, shining ivory. However, even the best surface in the course of time became covered with tiny fissures called *craquelures*. This does not spoil an old icon but, on the contrary, gives it a special fascination and an air of antiquity.

Paints were then applied to the white, shining surface. In the old days these were natural colours, dissolved in yolk of egg. Cinnabar was real cinnabar, ochre was real ochre. The old artists were especially fond of ochre, using it for faces and for the borders of icon, and often for the background. In very old and valuable icons the background is often of pure gold.

To make a large icon, several strips of wood were fastened together by dowels or cleats to make a single panel; these also prevented warping. They showed me the back of a small icon, and here too I could see that two cleats had been fixed across it. The icon being on a single panel, there was nothing to fasten together, and the cleats were only there to prevent warping.

While my hosts were explaining all this, the minutes went by and it was time to return to the operating table. The weight was removed, the glass lifted by one corner and taken off the flannel. The latter, which had been a bright green in colour, was now tinted dark brown from the panel below. The dark stain had seeped right through the flannel and was visible as a sticky, oily perspiration on the glass.

Then they began to peel off the flannel, holding it by one corner. It stuck closely to the board, almost like something that had 'caught' in a saucepan, but finally it came off, and I saw that the black surface beneath had, as it were, swollen and loosened. Without a moment's delay Nina took a small piece of cotton wool, compressed it into a wad which she dipped into the same stinking chemical (to me it was by now the pleasantest smell on earth), and moved it to and fro over the loosened varnish. The result was like a conjuring trick. All the black came off on to the cotton wool, and the place where it had been was ablaze with vivid red and deep blue. It took one's breath away. I felt as if I had seen a miracle: it was unbelievable that such intense, radiant colour had lurked beneath the repellent, dull black surface.

'Gently, Nina, treat it lovingly, don't get excited,' my host kept urging as his wife reached for the scalpel. With precise but firm, even movements of the razor-sharp instrument she cleaned off the remaining traces of varnish where they had stuck most firmly to the rectangular patch and had not come away with the cotton wool. Now at last we were really looking through an aperture in the dark curtain. On the other side of it everything was bright and festive, red and blue, sunny and lively, while we on this side remained in a dull, drab, gloomy world. It was like looking at a bright screen from the dark of an auditorium – a screen showing a different period of time, a different beauty, a life other than ours.

Another planet, another civilisation, a mysterious, fairy world.

Suddenly, to my surprise, I heard my friend saying: 'No, that's no good.'

'What do you mean, it's no good? It's beautiful!'

'Beautiful? It's a clumsy daub. Look at the thick, awkward lines. And the robes are painted in a single flat colour, without any variation. It's as dull and mediocre as can be. As Pushkin says, "The barbarous painter with his sleepy brush begrimes the work of a genius." You see, Nina, it's obviously an over-painting, we must get deeper down.'

'What's an overpainting?' I asked, puzzled, 'and what do you mean by "deeper down"? Down to the panel itself, or the ivory-like gesso?'

'Oh, dear me, no. You see, we've only taken off one layer of varnish, and we don't know what's coming next. It may be nothing at all – we're taking that much of a risk. But this painting would be no loss anyway, while if there *is* something beneath it. . . .'

'But what can there be underneath?'

'Another layer of black oil, and under that a masterpiece! The point is that in the old days, when the fixing-oil turned black they didn't throw the icon away. They called in an icon-painter who restored it, or rather repainted it using the outlines that were just visible through the varnish. When this was done they would revarnish it, and then the new picture would get black in its turn and have to be restored and re-painted. So, if you divide five hundred by eighty, you can work out how many layers of painting and varnish there may be on an icon which dates from the fourteenth or fifteenth century. Rublev's Trinity had to be cleared of several layers of later painting before they got down to the original, what restorers call the "authentic" level. Under that, of course,

there's nothing but gesso, and if you carelessly erase part of the authentic picture it's destroyed for ever. But who cares about this daub here? We'll get rid of it and cut another window in the blank wall, through to the sixteenth century I expect.'

'What's the date of this one?'

'End of the eighteenth, and a poor specimen at that.'

All this was bewildering, but I was content to listen and watch. The flannel was applied again, not to a layer of varnish this time but to the bright colours, as if to a live, palpitating wound. Then the chemical once more, the sheet of glass, the two-pound weight and the minutes of expectation. Meanwhile I went on imbibing knowledge about old Russian painting.

'Yes, there was a time when we didn't even know that these beautiful old works existed. By the beginning of the fourteenth century the paintings of the eleventh and twelfth had been covered over, and the people of the fifteenth century were ignorant of the thirteenth for the same reason; the sixteenth knew nothing of the fourteenth, and fifteenth-century icons were well and truly hidden by the end of the seventeenth. In the nineteenth century all people could see were eighteenth-century ones, and they were half-hidden by overlays of copper, silver or gold. We don't know who first came upon the truth, or how – probably it was some lucky accident. In the course of time a later painting may have started to flake or peel off, like plaster from a wall, revealing a glimpse of the ancient work underneath, and suddenly it would have dawned on the person looking at it that underneath was not just a small red blob but an ocean of colour and beauty, a lost world, a whole civilisation.

'The man who did get the idea and uncovered the first icon in this way deserves a monument, but we don't know who he was and probably we never shall. But the discovery shook the

artistic world like an earthquake. Lots of people started to collect and restore icons, liberating the original beauty from the later accretions. Some made themselves specialists in the business.'

'Don't you consider yourself a specialist?'

'If you compare it with surgery, I'm about on the level of a man who knows how to pull a tooth, amputate a finger or, at most, remove an appendix. But the real art is like the most delicate neuro-surgery, for instance when they operate through a nostril to remove a tumour from the back of the brain. Anyway, that was when the first great Russian collections began to be made: by Ostroukhov, Likhachev, the million-aire Riabushinsky or Victor Vasnetsov.'

'Where are all those collections now?'

'In museums, like the Tretyakov Gallery, the Russian Museum in Leningrad, or the Hermitage.'

'And are there no private collections left any more, not even as big as yours for instance?'

'Why, what sort of collection do you call this? I have just a few icons, two or three of which are really worth notice. But private collections do still exist. Of course, it's more trouble and expense than collecting matchboxes or wine-labels. It's no easy matter to buy a good icon, though it can be done. They usually pass from one collector to another. It's cheaper if you can find one in the attic of an old woman's house or an old ruined church; but then you have to restore it yourself, and that will cost you just as much as buying one that you can hang straight on to the wall . . . but stop, it's time to have a look at what's happening under that weight of ours.'

I must admit that although, when we removed the varnish on the first occasion, I had expected to see something of interest underneath, though I had no idea how impressive it would be, at this second attempt I had no expectations whatever. I could

not believe that another painting would be found underneath the first one – it seemed a mere fancy, a promise incapable of fulfilment. How could there be another painting, when the robes and folds and everything on this one were so real and visible and expressive? How was it possible for a different one to materialise, let alone a better one?

My friends repeated the same procedure: they laid the weight to one side, lifted off the glass by its corner and removed the flannel from the paint, which swelled and loosened under the effect of the chemical as the varnish had done before. A single, long movement with the scalpel, held at a low angle, brought it away from the surface in the thinnest of flakes.

'Gently, Nina, treat it lovingly, don't get excited . . . Aha! I told you we should find a jewel this time. Gently, Nina, lovingly!'

We all held our breath. Under the sharp, accurate scalpel, under the colouring which I too began to find garish, there came into view a painting of such delicacy that it was like magic or a fairy-tale. Against a tender green background we could see two rows of pearls, evidently adorning the hem of the saint's robe.

'Pearls – sixteenth-century. Look at the bold, energetic line, look at that delicate strip of white! "But as years pass, the alien colours grow old and flake away: we see the genius's work in its primal beauty." Only we shan't wait for the colours to flake away of themselves – nature, as Michurin says, doesn't confer favours on mankind.'

So there the three of us were in our different attitudes. Nina, with a quiet smile of contentment on her face, went on cleaning the surface of the exposed rectangle; my friend walked round the icon ecstatically quoting Pushkin and Michurin; as for me, I couldn't see myself, but I am sure that my expression was one of stupefaction.

The rectangle had become even brighter and more radiant than before. We three, in the modern studio, were still on the wrong side of the dark curtain; but one felt that if the whole icon were cleaned, with the saint's countenance, his sword and the city he was defending, it would become lighter on this side too. Meanwhile, as if enchanted, we gazed through the tiny opening into the sixteenth century, so bright and dazzling that it hurt one's eyes.

After all I had seen and been told, I was able to ask one reasonable question: how was it possible, in an old woman's attic or storeroom or in a derelict church, to tell whether a particular icon would reveal an ancient painting or consist of nothing but modern paint and an ordinary plank of wood?

'You can tell by the panel itself. Certainly not by the painting, which might be of sky-blue cherubim and baby angels, straight off a picture postcard – nineteenth century, obviously. But if you look at the back of the panel, or its sides and ends, you may discover that it's much older than the painting, and in that case it means that there's ancient work underneath.'

'But how do you know that it's older – I suppose there are particular signs?'

'It's a whole subject in itself. Of course there are some signs. Suppose, for instance, you are shown a man's photograph and want to know what period it belongs to. Let's say he's wearing wide trousers. Some men, of course, still wear them now, in the sixties, but in general they belong to the pre-war decade. However, a single indication is not enough for certainty, so we look for something else. Before the war men had their hair cut short at the back and they tied their ties in great floppy knots and wore collar-studs of a cuff-link type. Then again in the sixties there was a time when jackets were made with a single slit at the back, and later on they had two. And so, when a lot

of signs like that coincide you can tell the date of the photograph exactly. In the same way, we know what century an icon-panel belongs to. The way in which the back is treated and the boards joined to form a single panel, the type of cleats used, their distance from the ends of the panel, its thickness and pro-portions – all sorts of things. For instance, there is what we call the "ark" shape. As you know, the painted surface is hollowed out so that the edges of the icon stand out by a few millimetres. This bevelled edge is called the "ark" and is one of the first and surest signs of age. Of course a nineteenth-century artist might imitate it, but the point is that a sixteenth-century artist would always make an icon that way. So if you're en-couraged by our example and want to purchase an icon, that's one of the first things you should look at . . . Didn't you say you were spending the summer holidays in your own part of the country, around Vladimir? I suppose there are plenty of derelict churches thereabouts?'

'Yes, there certainly are.'

'I think Nina and I might come and visit you there for a week or so and look about the countryside. We'd soon show you how to tell an old icon from a modern one.'

3

I ARRIVED in my old village, and set about my usual country occupations. I equipped myself for work, that is to say I cleared everything off my desk except a ream of paper and an inkpot; I went bathing every day, but first of all, as soon as I arrived, I took a walk in the forest. By the morning of the second day I already had some written work to show. My way of life was exactly the same as in previous summers, but something had changed in me. For instance, ever since I was ten I had been in and out of the house next door, which belonged to 'Uncle Nikita' Kuzov, but I had never noticed what he kept in the 'front corner' – the place of honour where icons used always to be hung.

Uncle Nikita had just left the 'friendly circle', as the peasants called their monthly drinking-bout. I had gone to see him because I wanted a saw sharpened.

'Hallo, Uncle Nikita, how are things?'

'Oh, they're getting better. I wish it was the third today.'

'Why, what's so good about that?'

'It's the day the postwoman brings me my pension.'

'Listen, could you sharpen a saw for me?'

'A saw?'

'Yes, a saw. Mine's blunt, I can't work with it.'

'Why not? Of course I'll sharpen it for you.'

'I thought you might find it a bit hard after the "circle", your hand'll be shaking.'

'Well, you know the saying – a drunk can sleep it off, but a fool can't. Bring along your saw.'

While we were talking, my eye had fallen on the 'front corner' of the hut. For over twenty years I had glanced at the spot dozens and hundreds of times, but now, as it were, I stumbled on it and it held me spellbound. Hanging in the corner was a large coal-black panel. I went up and gazed at it.

'Interests you, does it? Take it over to the window, you'll see better.'

I undid the string, greasy from the generations of flies that had lighted on it, took down the icon and held it by the window, facing the light. Through the blackness, the soot and grime and the cracked drying-oil I could just see the dark cherry-coloured robes of a saint, who was depicted full-length. He wore a crown and seemed to be carrying a censer, and one could guess at delicate gold patterns on the dark robe. When I looked at the icon sideways, at an oblique angle, parts of it seemed to be in relief, and I imagined these to be the places where a later artist had slapped on his barbarous colours. For a long time, until I acquired some skill in distinguishing icons, I invariably suspected the existence of several layers of accretion: I could not forget the sight of the hole cut in the darkness, revealing a radiant ancient world.

'I say, Uncle Nikita, where did you get this?'

'From the old church at Fetinino. I lived there when I was working as a blacksmith on the collective farm. When they closed the church, it was full to bursting of icons like this.'

'What happened to them all? Maybe they were thrown into a shed somewhere and are still . . .'

'Not a bit of it, they were all used up.'

'What do you mean, used up?'

'They knocked them together to make crates for potatoes.'

'Then perhaps the crates are still there. If I were to go to the farm . . .'

'You wouldn't find anything. Even while I was there, the crates all disappeared.'

'But they couldn't just evaporate. What happened to them?'

'Well, what does happen to things? Anyway, I got this icon from the Sanctuary – it was newer and shinier in those days. Now it's all so black you can't see a thing.'

'Then you might as well give it to me.'

'All right – take it if you want to.'

*

And thus I became the possessor of a black, ancient icon. When I went to see Uncle Nikita I had nothing on my mind except to ask him to sharpen a saw. I had no idea that from being an ordinary mortal, plagued with dozens and hundreds of petty cares, I should be transformed in the space of half an hour into a collector, and all those hundreds of cares, desires and efforts would be fused into one single desire, one intense preoccupation as overmastering as a fever. When I set out to see Uncle Nikita I was one person, and now I was a different one. Of course the transformation was prepared by what I had seen and heard at the studio, and by all sorts of other circumstances that I need not go into here. Nevertheless, it took place at the very moment when Uncle Nikita presented me with the icon he had rescued from the church at Fetinino, and which I now took home with me.

I examined it from all sides, a prey to conflicting feelings. There were no cleats on the back; I had been told that every icon had these, and did not know if their absence was a good or bad sign. The panel had been made by scraping, not planing, which suggested that it was old. The picture was black, but it was not recessed in the way I had been told was a sign of age.

I laid the icon on a table, poured some sunflower-seed oil

into a saucer, took some cotton wool and rubbed it cautiously over the picture. The dark cherry colour began to glimmer more strongly through the black. I would have tried applying a flannel 'compress', with a sheet of glass and a weight, but I had none of my artist friend's chemical, or any spirit that might have done instead of a stronger solvent. I did not even have any liquid ammonia, so the sunflower-seed oil had to suffice. As it was beginning to dry I rubbed the icon once again: the painting became clearer still, and I felt a tremendous thrill of pleasure.

When one acquires the first object of any collection, one is feverishly eager to acquire more as quickly as possible. The last thing you think of is that a proper collection takes years and even decades to complete – you want to have the whole thing in three days . . . Later, when Pavel Korin showed me his collection of icons – the best private one in Russia, and therefore in the world – he said: 'It's not a simple matter, and it takes a lot of money. My collection was quite different from this at the start, but afterwards I began to select. For five bad icons you can get one average one, and for three average, one good one. For three good ones you can get one first-class specimen, a work of astounding beauty. It has taken me forty years to build up this collection of perfectly splendid icons. I put into it every penny I made by my work as an artist.'

It was there in Korin's studio that I realised once again, or perhaps for the first time, what a difference there is between one kind of collection and another. It would be strange indeed if such a man and such an artist as he were to collect buttons or sea-shells, butterflies or birds' eggs: a petty, incongruous, senseless habit, a mere whim, as opposed to a mission, a life-work and a glorious achievement. Passion is a human feeling that may be the same in everyone, but its objects are very different.

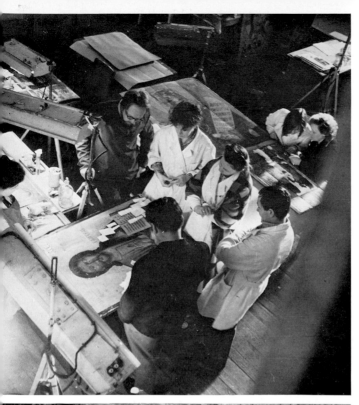

Restorers discuss-
ing an icon of the
northern school

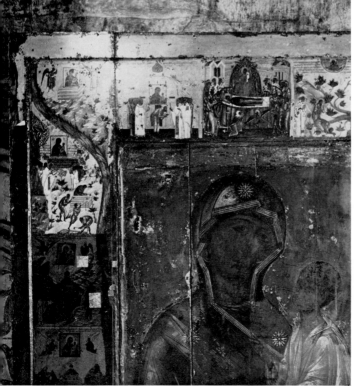

'The Virgin of
Tikhvin', 16th
century, dis-
covered after
restorers removed
the top layer of
the painting

This magnificent art of our forefathers ... owing to all kinds of events and circumstances, how many specimens have already been lost! Old, defaced icons have been thrown into the river, burnt at crossroads, cleared out of attics. Others are being lost at this very moment. Is it not a noble occupation to find and save them, to preserve even a single one of these paintings, to spend one's own earnings on cleaning and restoring it so that others can admire its beauty? Surely a single work of genuine art is worth many tons of sea-shells, even if they formed the most unique collection in the world.

'As long as I live,' Pavel said to me, 'I shall admire them, breathe in their beauty and be nourished by their spirit. After that, I shall bequeath them to the State. I can see your eyes shining. Perhaps you too will be a collector one day, perhaps you will manage to find some old icons and save them from destruction. Always remember that they are great works of art. A collection of shells or butterflies is just that and no more, but when you collect old Russian paintings you are collecting the nation's soul.'

Well, for the time being I had just the one black icon that Nikita had given me. Every half-hour I rubbed it with oil, peering into its black surface and convincing myself that I had got hold of a real masterpiece, a genuine antique. I was as happy as a child that thinks there will never again be a piece of cake so nice as the one it is now eating.

Two days later, I found various pretexts for going into every house in the village. I would be talking, for instance, to old Polya Moskovkina while my eyes wandered avidly towards the 'front corner' where, sure enough, every hut had its icon. In a casual tone I said to her:

'Well, well, I see you still have some icons.'

'Of course I have, master Volodya. Icons, to be sure, how could we get on without them? The young folks today don't

care about God, that's their business, but we old people stick to our icons.'

'Could I have a look?'

'Of course you can, dear, look as much as you like.'

I stood on the bench and looked at the icons. I knew nothing about them in those days. Each one, I felt, was bound to be a masterpiece, a bright marvel of beauty covered under the work of later painters. Whenever I saw one I wanted to take it straight home and find out. But I had not the face to demand an icon from its place of honour, nor would the owner have parted with it. So I left every home feeling that I had lost part of my heart there – that it contained a precious object that ought to have been mine but which, by some foolish accident, belonged to others who could not appreciate it as I could.

As if she could read my thoughts and hopes, Polya said:

'Vera Kuzmina has a lot of icons in her storeroom. There was one of St George the Great Martyr – they used to bless the cattle with it in spring. Vera's father-in-law, Vassily Yegorovich, used to keep it in his house.'

'Bless the cattle – how did they do that? What was the idea?'

'It was the custom. When the cattle were driven out to pasture after the winter, on the very first day, they always carried the icon round in a procession. There were special prayers against wild beasts, the plague, the evil eye and so on. And the procession always started from Vassily Yegorovich's house. The icon should be in Vera's storeroom now, but of course she may have burnt it long ago.'

Vera Nikitichna – her full name – had in former times been a companion of my elder sisters: according to her they had had wild times together, or 'carried on' as she called it.

'Yes, of course I used to carry on with your sisters Katyusha and Valentina, and Nina Voronina as well. Your parents went

off to market and left us girls to keep house, and we would get at the honey or start making pies or stuffed cabbage-rolls and have a high old time. When you were a baby they left you with us, and you used to cry your head off when we wanted to fool about. You were a year old or maybe less. We used to go and raid Aunt Nastya's garden for apples – she was your neighbour, an old woman who couldn't see a thing, and so we went after the apples. Oh, yes, I used to have fun with your sisters Katyusha and Valentina, and Nina Voronina as well. But when you once started screaming, the only way of stopping you was to bang the cupboard door. When we did that you would stop, but as soon as we left off you would start screaming again, so we took turns banging it. And your parents used to bring us back things from the fair; hair-ribbons, combs, all sorts of finery.'

These idyllic recollections of my sisters must surely redound to my benefit in some degree. In later years life had dealt harshly with Vera Nikitichna, who was now middle-aged, and had spoilt her temper in some ways, but I nevertheless felt confident that if she did possess the icon of St George the Victorious, with which they used to bless the cattle in spring, then she would give it to me.

The house she lived in was a large one that had belonged to her father-in-law, the pious old Vassily Yegorovich (Yegor means George, and it was because of this, and in honour of his own father, that he kept the icon in his house) and his wife Yevlenia. The whole family had lived together, but Vera married her only daughter off to a lad from another village, and Vera's own husband, who would have inherited the house, had gone off with a young widow, so that she was left alone in it. This, then, was the Vera Nikitichna to whom I came in search of the victorious icon that had been used to bless our cattle in olden days.

'Of course they did,' she replied at once. 'It was always carried around. They wouldn't have dreamt of doing without it.'

She took me to her lumber-room, a part of the house which usually contained a bin of flour and various implements. Apart from that it might be used, when tidied, as a bedroom, generally for a young lad or girl, who slept on top of a large chest on which bedding was arranged. The one in Vera's house was spacious and, in better times, had been a summer living-room. It had a tiny window such as you might see in a bath-house. In the far corner a glimmer of golden light was visible in the dusk.

The iconostasis – for such it was – consisted of planed posts and laths fastened together so as to form five horizontal sections: two were empty and the others full, like special cells in a bee-hive. And there, beside the iconostasis, was the victorious St George himself.

In this way I became the owner of five whole icons. The large black one from the former church at Fetinino, with the barely visible painting of a saint in dark cherry-coloured robes, with a censer in one hand. St George the Victorious, who was all the dearer to me because he had been used to bless our own cattle. Even if there had been nothing left of the icon but a panel and a crumbling picture I should have thought it worth keeping, because our forefathers had held the picture in their hands, and one could imagine the scene. On a May meadow, coloured with the first tender green of spring, cows, calves and sheep are grazing. The whole village is there too, from the old men who have put on clean smocks for the occasion to the children in red and blue shirts; and here is the priest, Father Alexander, with the deacon, Nikolay Vassilyevich Nadezhdin, their vestments glittering in the spring sunlight as they swing the fragrant censer and solemnly sprinkle the herd with

holy water from an old copper pitcher (which also later became my property). Walking round the herd with them would be the greybeard Vassily Yegorovich, carrying the icon of St George on a linen cloth. Yes, one could imagine the scene. Someone might even have painted it on canvas, and if I had seen it I would have sighed and remembered that there must indeed have been an icon that was carried out in procession on that day. If only it had been preserved, if only one knew where to search and could actually find it!

Imagine my feelings, then, when I held in my hands the icon itself, the very same one! It was nearly as black as my first find, but one could just see St George on his rearing horse, which was a white one, and around its feet the coils of the dragon pierced by the champion's invincible lance. One could also see the wings of the cloak behind the hero's shoulders.

The three other icons that Vera Nikitichna gave me were newer and brighter-looking. One of them was a half-length picture of Christ with a book in his hand, another represented the Virgin, and the third figure was of someone else who resembled Christ but was not he. It will be seen that in those early days I had not learnt to distinguish between Christ and St John the Baptist.

The icon of St George was painted on a thick, unusually heavy panel – I learnt afterwards that it was of cypress wood. The others were very thin, and as light as straw in comparison. The boards had warped and the cleats had disappeared, except for one that was loose in its groove and could be moved in and out without difficulty. The other side of the boards was smooth and bright, unlike the glossy black of very old, small household icons.

I stood all five in a row in the empty back room of our house. In an hour at most, I could not resist going in to admire them again. I laid them in a pile, with soft rags in between, to

see how I could best transport them to Moscow; then I arranged them again in a row, trying one order after another; then I looked at each one separately, carrying it over to the light. In short, I did everything that an ordinary man in his senses would not have done. Every passion is a kind of disease, a deviation from the norm. The great mistake people make is that they expect a man in the grip of a passion to behave like someone who is not, and they usually judge his actions by themselves and their own standards of cold-blooded sanity. Poor dispassionate people – how sorry one feels for them!

4

HAVING taken a thorough look round my own village, I turned my attention to the neighbouring ones. I did not as yet go round the houses asking whether they had any old icons, but I began to think and search my memory, wondering in which houses they might be found.

The house I thought of most was the priest's in the nearby village of Snegirevo. This village was built along a stream in a valley, and the windows of the houses looked out on to a high hill covered with fir-trees. At the summit, a small bell-tower could be seen between the tops of the trees. From a distance it looked as if the trees stood close round the church, but when you came up to it you found that the church was surrounded by a large clearing, in fact a neglected park. Among the shrubs and nettles in the clearing were pinkish heaps of rubble. This had once been an estate belonging to the princely family of Saltykov, and on it had stood a splendid mansion with outhouses, stables and even a conservatory.

Close to the church, in a dilapidated condition, was the Saltykov family vault. In a book, of which I shall have more to say presently, I read the following about Snegirevo:

Until 1813 Snegirevo was a hamlet and its parishioners belonged to the church in the village of Spasskoye-Savelovykh. In that year the village landowner, General Fieldmarshal Prince Nikolay Ivanovich Saltykov, erected at his own expense in Snegirevo a church and belfry, both built in stone, and these became the centre of a parish. In the vault attached to the church are the remains of Prince Nikolay Ivanovich (d. 24 May 1816), his wife Natalya Vladimirovna (d. 7 September 1812), their son Prince Sergey Nikolayevich

39

(d. 25 April 1828) and their grandson Prince Aleksey Dmitrievich (d. 1859).

The Brockhaus and Efron Encyclopaedia (volume 50, page 156) had the following to say about the church's founder:

Saltykov (Prince Nikolay Ivanovich, 1736–1816): General Field-marshal; fought in the Seven Years' War. Assisted Prince Golitsyn in the capture of Khotin, 1769. From 1783 he was in charge of the education of the Grand Dukes Aleksandr and Constantine Pavlovich. In 1784 he became a Senator and member of Her Imperial Majesty's Privy Council (now the Council of State); in 1788 he was Vice-President, and in 1790 full President, of the Army Department (Collegium). From 1812 he was President of the State Council and the Cabinet of Ministers. The dignity of Prince was conferred on him in 1814.

In the same village of Snegirevo there was formerly a priest named Father Ivan, known for his wide reading and culture and what one would nowadays call the breadth of his views. Certainly he was a man of firm convictions. It is related that pressure was put on him to leave the priesthood, but he replied that having once taken orders he would not divest himself of them voluntarily.

I had seen him once or twice as a small boy, and remembered his snowy, Father Christmas-like beard and blue spectacles. I also remembered a striking remark of his, when he pointed to a picture of Stalin that hung on the wall of his room, keeping rather strange company with the icons, and said: 'You know, what I like about him is the style.' There were just the two of us with him on this occasion: my father, a peasant who had never taken any interest in politics and probably failed to appreciate Father Ivan's cheerful judgement, and myself, aged only seven but capable of remembering the white beard, the spectacles, the picture of Stalin and the tone in which Father Ivan spoke of him. Another impression that stayed in my mind was that of a reddish-golden object in the 'front corner': I

even remembered the little flame of the lamp burning before the icon, and the lamp itself, shaped like a china dove in flight.

I had heard since that Father Ivan had died and that his grand-daughter* and her husband were now living in his house: both of them had been early schoolmates of mine. So I decided now to go and see them and discover the reality that corresponded to my vague recollections of something reddish, golden and glowing.

The room looked very different now. In Father Ivan's day one had not noticed the wallpaper, but now it was bright and garish. Another 'loud' feature was a reproduction of the Vasnetsov picture of the Three Warriors, which the present master of the house had painted over a large icon from the church.

'I suppose you scraped off the religious picture first?'

'No, I painted the other straight on top of it.'

I thought to myself how easy it would be to erase the blue and green oils that represented the Warriors; but there was not the least chance of their creator permitting the destruction of his work simply in order to set free an icon.

'Are there any other of your grandfather's icons left?'

'There are some lying about in the storeroom.'

The dusty bits and pieces that I found there did not go far to reconstruct my childhood memory of a golden mosaic, lit by the ruby glow of the lamp. They were mediocre icons of recent date in heavy glazed frames. My friends allowed me to search for the few that were of any real interest, but by and large it was a profitless quest.

'He left two books you might like to borrow – historical ones. But don't forget to return them – I'm fond of reading about old times.'

I expected some kind of trumpery historical romances, but

* Most Orthodox priests are married.

the books turned out to be fat volumes with small pages, the spines clad in black leather with faded gold lettering. The front and back were decorated with imitation-marble veining, as was common at the end of the nineteenth and beginning of the twentieth century. The books were in fact published in 1893 and 1896, and one had to bear in mind that their contents related to that period. They were entitled 'An historical and statistical descriptive guide to the churches and parishes of the Vladimir diocese'. The first volume covered the districts of Vladimir, Pereyaslavl, Aleksandrov, Shuya, Kovrov, Vyazniki and Gorokhovets, and the second volume the remainder: Suzdal, Yuryev, Melenki, Murom, Pokrov and Sudogda.

When I took these volumes home, I did not suspect that for some time to come I should be reading practically nothing else. The information they provided was dry and matter-of-fact. The preface stated:

The purpose of this work is, on the one hand, to record as far as possible the history of the churches and parishes of the Vladimir diocese, indicating those sacred relics of the past that are still preserved there, and on the other hand to describe their present condition. The territory which now constitutes the diocese has a background of many centuries, each of which has left some trace on its places of worship and habitation; so that in establishing the record of its churches and settlements we shall be studying the history of the area in greater detail than is common in the majority of historical works. The work should therefore afford pleasure to all who love our country's religious past. At the same time it may serve as a work of reference for the diocesan clergy: for instance, if a priest should be transferred to another parish he will find here all necessary information concerning the number of souls, the parish revenue, houses, etc.

At the time of which I am writing – 1961 – the books were over sixty years old, but to read them was like going back several centuries. It was rather as if one were to tour modern Greece equipped with a guidebook describing the age of Solon,

42

or Italy with a guide to ancient Rome, or modern Europe with a handbook describing mediaeval castles and knights and perhaps giving the timetable of the season's tournaments. Of course the place-names would still be the same – Athens, Rome, the Peloponnese, the châteaux of the Loire, Edinburgh, Seville . . .

Supposing any member of what was left of the clergy today should want to move from one parish to another, would this guide still be of any use to him? If, for instance, he chose the village of Stavrovo – 'an ancient, prosperous trading village with two churches, fairs at regular intervals and twelve refreshment houses' – what would he make of *Berezka* [a secular holiday], the football stadium and a timetable of the buses running to Stavrovo?

Having said so much about these books which came into my hands by chance, I realise that one cannot really form much idea of a book unless one has read a few pages from it. Since these volumes are so rare, I will venture to quote an extract dealing with Stavrovo, which I mentioned just now. This may serve to show the style and content of the book and its immeasurable distance from present-day reality.

*

STAVROVO

The village of Stavrovo is situated at a distance of twenty-five versts from Vladimir in a large, pleasant valley on the right bank of the Koloksha, a tributary of the Klyazma. According to tradition it was a residence of Princess Anne of Byzantium, the second wife of the Grand Duke Vsevolod, whom he married in 1206: she is said to have named the village from the Greek word for 'cross' – *stauros* – but for what reason is not known. The stone crosses found in the neighbourhood also bear witness to the village's antiquity. It is first mentioned in ancient documents in a 'grant of privileges' by the Grand Duke Vassily Ivanovich of Vladimir to the cathedral of

St Demetrius, dated 4 March 1515. Here it is mentioned along with other 'villages of the ducal domain' on which a tax in money and kind was imposed for the benefit of the pious woman who made Communion bread for the cathedral. 'The peasants of Stavrovo village shall pay every year two quarters of rye, a quarter of wheat and as many peas as will fill a sieve, and two *denga** for salt and timber.'

In 1628 the village is mentioned in the parish and fiscal records of the Moscow Patriarchate as the property of Her Majesty the Tsarina and nun, Paraskeva Mikhailovna. From 1632 it became an estate of the Convent of the Ascension in Moscow, to which it was granted, as appears from the census book of 1650, by the Tsar Mikhail Fedorovich in eternal memory of its late owner the Tsarina Pelageya, 'known in religion as Paraskeva'. It remained an estate of the Convent until 1764, when it was placed under the Administration of State Property.

The village church is thus described in the Patriarchal records of 1628: 'The church of the great miracle-worker St Nicholas in the village of Stavrovo, an estate of Her Majesty the Tsarina and nun, Paraskeva Mikhailovna, is assessed in accordance with the Imperial grant for two roubles twenty-five *altyn** two *denga*, which sum was discharged by the parish priest Father Ivan on the twenty-eighth day of January in this present year since the Creation seven thousand, one hundred and thirty-six.' Besides St Nicholas' church at Stavrovo there is also a church of the Dormition of the Blessed Mother of God with a chapel dedicated to the holy prophet Elijah: 'both churches are of wood and contain images, candles, vestments and books; all secular buildings appertaining thereto are on church land. The village clergy are Ivan Demidov and Semyon Ivanov, priests; Ilyushka and Vaska Fedorov, deacon and sub-deacon; Maritsa, daughter of Pakhom, baker of Communion bread. There are the premises of the Convent and its officials and the rural clerk, twenty-eight peasant homesteads and fifteen cottagers.'

At the beginning of the eighteenth century it pleased God to allow St Nicholas' church to be destroyed by fire. The Office of the Patriarchate ordered a new one to be built, also of wood and dedicated to St Nicholas: it was consecrated in 1718 and stood until 1813, when it too was burnt down. By the parishioners' desire and at their expense a stone church was then erected in honour of the

* Ancient coin.

Most Holy Trinity, and this building survives to the present day. The church of the Dormition was restored in 1720 by permission of the Patriarchate, also at the parishioners' expense, and stood until 1798. It was then demolished, as it was falling into disrepair, and replaced, at the parishioners' wish, by a five-domed church, also in honour of the Dormition of the Blessed Virgin, which survives to the present day.

There are thus two churches at Stavrovo, that of the Dormition and that of the Trinity. The former contains three altars, dedicated to the Dormition, the Prophet Elijah and St Sergius of Radonezh, the Wonder-Worker: this last was built and consecrated in 1877. The church of the Blessed Trinity has five altars, dedicated respectively to the Trinity, the Intercession of the Mother of God, St Nicholas the Wonder-Worker, St John the Divine and the Great Martyr St George. Both churches and the bell-tower are of stone, and in 1877 a new stone enclosure was built around them.

Copies of the registers of the church of the Dormition exist in an unbroken series from 1806, and those of the church of the Trinity from 1831; the records of attendance at confession from 1829 are kept in the church. There is an inventory of church property.

The following sacred objects are worthy of note: (1) a silver-gilt pectoral cross with morsels of the holy relics of the Great Martyr St Panteleimon. Four small stones are set into the cross on the front side, and at the back, opposite each, are engraved the words: 'A stone of the Lord's blood' (at the top); 'A stone from Mount Calvary' and 'A stone from the Mount of Olives' (at either side); and 'A stone from Bethlehem' (at the bottom). This cross was presented to the church by a peasant of the parish, but its origin is unknown. (2) An altar-cross of chased silver dating from 1730. (3) Ancient local icons of the Saviour and the Virgin of Kazan. (4) An ancient image of St Simeon Stylites, painted on stone, in a shrine near the church of the Dormition. (5) An ancient image of St Nicholas the Wonder-Worker, with silver-gilt ornamentation, in a shrine at the hamlet of Dobrynino: this image is especially venerated by the faithful of the parish. Among the books may be mentioned: (1) A service-book printed in Moscow in 1676. (2) A menologion [cycle of saints' lives for the year] printed in Moscow in 1693. (3) A copy of the Gospels on folio Alexandria paper, weighing two *puds* and ten pounds [about 80 pounds]. The front is covered in silver-gilt and decorated with five enamel overlays surrounded by garnets and depicting the Resurrection together

with symbolic animals. The back is covered in silvered brass and depicts the house of Holy Wisdom. She is seen seated on a throne in the centre, holding an orb and sceptre; before her stands David with an open book displaying the words 'I was a staff unto my brethren', and Solomon bearing a lance in one hand and a helmet in the other, with a shield lying at his feet. The back of the volume is bound in copper, with symbols of the Old and New Testament. Two Evangelists are depicted on the two copper clasps, and each Evangelist is portrayed by hand in Indian ink at the beginning of his Gospel. It is not known by whom or when the volume was presented.

Church buildings: (1) a chapel in the hamlet of Dobrynino dedicated to the Blessed Mother of God. In the same hamlet, in a field, a shrine dedicated to St Nicholas the Wonder-Worker. In the hamlet of Bely Dvor, a stone shrine dedicated to the Smolensk icon of the Mother of God. In the hamlet of Bogatishchevo, in a field, a wooden shrine dedicated to the holy prophet Elijah. In the village, by the church of the Dormition, a stone shrine in honour of St Simeon Stylites: on the first day of September each year a parish procession took place here for the purpose of prayer and blessing the waters. In the hamlet of Toltukhovo, a stone shrine erected in 1885. (2) Houses and shops. A two-storied stone house with a sheet-iron roof: the village school for girls occupies the top story, and the teacher lives below. The school is heated with part of the wood assigned to the church, and in return for this the village pays 50 roubles a year. A single-storey wooden house on a stone foundation, a sheet-iron roof: this is used by the postal authorities, who pay the church 120 roubles a year. Shops (booths) built of stone and roofed with sheet-iron bring the church an income of 1,058 roubles a year.

The clergy consists, according to the authorised establishment, of three priests, a deacon and two precentors.

The parish consists of the village (202 homes) and the hamlets of Dobrynino, Sheldyakovo, Yermonino, Bogatishchevo, Fomino, Bely Dvor, Filino, Monakovo, Yerosovo, Ostafyevo, Pesteryugino, Tolpukhovo, Ryzhkovo, Vysokoye, Sulukovo, Yagodnoye, Luchinskoye, Novoselka and Teterinovo. These are all within five versts of the church, and the clergy have no special difficulties of access to them. The number of homes in the parish is 867, with 2,758 persons ['souls'] of the male sex and 2,952 females. In addition, the Old Believers* account for five homes in Monakovo and six in

* A sect which seceded from the Orthodox Church in the seventeenth century.

Vysokoye, with 35 persons of the male sex and 52 females.

There are two schools in Stavrovo village. A two-class school for boys, under the Ministry of Education, was opened in 1877 in a house built by a peasant named Bazhanov. The rural school for girls, also opened in 1877, occupies the church house mentioned above.

*

Princess Anne, the second wife of the Grand Duke Vsevolod of Suzdal, came to Russia from Byzantium. No doubt she maintained contact with her former home and managed to have things about her that reminded her of Constantinople – as Stavrovo, the name of her new residence, did. She must also surely have brought some sacred objects so as to have them always before her eyes, and the obvious ones to choose would have been icons, church books and church embroidery.

Can we suppose that there were no Byzantine icons in the church of the village that this princess from the imperial city chose to live in? In the first place, she may well have brought some with her; in the second, this was the early age of Christianity in Russia and there were many artists from Byzantium who painted icons for Russian churches and taught their art to Russian pupils. If the princess needed painters to adorn the church at Stavrovo she would most probably have chosen her compatriots. In addition, icons from her home may have found their way to the church and been kept there, and one or two might have survived till a much later period. But in that case, why was there nothing about them in the reference work from which I have quoted?

In the first place, the book does mention three ancient icons, of which only one cannot possibly belong to the thirteenth century, namely the Virgin of Kazan, since that city was not conquered from the Tatars until the middle of the sixteenth. The icon of St Nicholas and that of St Simeon painted on stone

might belong to any century, including the thirteenth when Princess Anne lived at Stavrovo. Again, the book often gives wrong information or none at all about the antiquity of icons and other objects. I could not always prove this, since many of the things mentioned have been destroyed or scattered, but here are two examples.

We know that the main iconostasis in the church of the Dormition at Vladimir was painted by Andrey Rublev and Daniel Cherny (the Black). We also know that when Catherine the Great decided to replace this iconostasis by a new one she ordered the old icons to be removed to the village of Vasilyevskoye near Shuya. In Soviet times the Tretyakov Gallery despatched a party of experts to Vasilyevskoye to trace and recover all the Rublev icons, so that we can now admire them without leaving Moscow. The magnificent Deesis, the size of which reflects the dimensions of the Vladimir cathedral, is among the Gallery's principal glories.

We should not condemn the Empress Catherine for preferring baroque icons to those of Rublev. The latter's work looked very different in her day as compared with now, when it has been carefully restored. The master's painting was concealed under layers of subsequent, mediocre work; the icons were dull and dim, without radiance or beauty. However, I mentioned the icons taken to Shuya by way of showing that the book I spoke of is sometimes inaccurate or incomplete. In its description of Vasilyevskoye it says nothing about Rublev's icons or any other antiquities, but merely mentions that the village church is 'very rich in holy icons, sacred vessels and vestments'.

Another and even more striking example concerns the church in my own village of Olepino: I found here several icons of the seventeenth century and one of the sixteenth, whereas the book only mentions an early Gospel printed in the

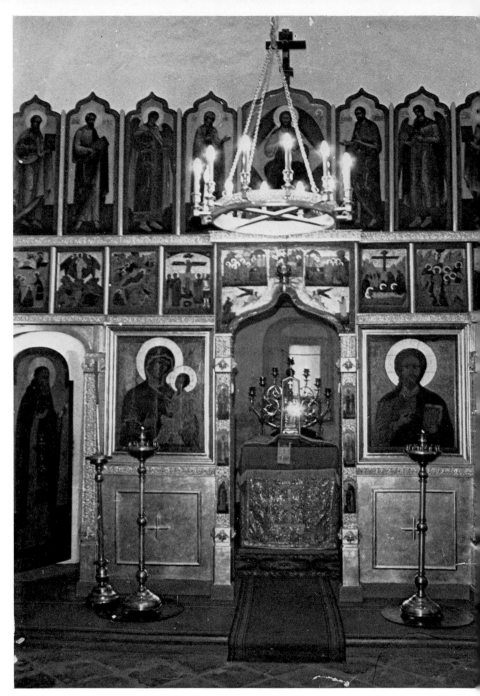

Traditional, small iconostasis of a Russian Orthodox church

time of the Patriarch Joseph. The oldest of these icons, which is also the best, was in a dark corner, concealed by a cheap brass frame and covered by an inferior oil painting.

I am convinced that in the two churches at Stavrovo there must have been some old icons, perhaps going back as far as Princess Anne's time; but they were no doubt painted over and half-concealed by metalwork, and in the course of time their existence would have been forgotten. As for the churches themselves, one was turned into a carpenter's workshop and the other became a machine-tractor station*. Both were invaded by tractors and trucks and piled high with barrels of fuel. The structure of the 'summer' church†, the one which became a tractor station, was originally strengthened by cramp-irons, and this fact hastened its downfall. The director of the station caught sight of the cramp-irons and ordered them to be stripped off and used for making nuts, bolts and other spares. (I am always startled by the casualness with which people make free with things that were not intended for their use.) The walls, thus weakened, became ready to collapse, and the vibration of the tractors did the rest. Where the church once stood there is now an open-air shooting gallery and dance floor. The 'winter' church is still a workshop and depot. Once when I wanted some cement I drove in and scraped my car against the entrance; it was very narrow, and I was still learning to drive in those days.

* State-owned depots for tractors, etc.
† Not heated for winter use.

5

EVEN though the book did not mention all the antiquities to be found in the innumerable churches of the Vladimir district, it was quite specific about those it did mention. However, it usually happened that after reading about all sorts of antique treasures one would go to the place and find a heap of rubble overgrown with nettles, or a collective farm depot with bare walls and windows stuffed with dirty rags. Yet passages such as this would excite one's imagination and egg one on to explore:

Village of Prechistaya Gora [Mountain of the *Purissima*]: 40 versts from Vladimir, on the small river Tom. About two centuries ago there was a convent here dedicated to the Intercession of the Mother of God. The dates of its foundation and dissolution are unknown. An ancient chapel with wooden icons stood on the site of the former conventual church until the thirties of the present [nineteenth] century, when it burnt down and only two icons were saved: those of the Ascension and of the Virgin of Bogolyubov (the Virgin of Compassion), which are preserved in the houses of peasants belonging to the parish. Another icon of the Mother of God, which previously belonged to the convent, is now in the village church at Yeltesunovo.

How much food for thought there is in that laconic paragraph! The Mountain of the *Purissima* – the convent of the Intercession, its dates of foundation and dissolution unknown . . . When a church was disused and pulled down, the custom was to erect a shrine or chapel on the spot and transfer the oldest icons to it. The shrine stood for centuries, while the convent became a vague legendary memory. The shrine stood and the icons remained in it – genuine ones from the convent

itself, living witnesses of its history. By dating them, one could tell when the convent itself had stood there . . .

In the 1830s – Pushkin was still alive then – the shrine had burnt down. Someone had carelessly dropped a candle, no doubt: the woodwork all around was drier than powder, it had had three or four hundred years to get that way. Up in flames went the old icons, masterpieces that would have graced any museum – there they were, burning to ashes at Prechistaya Gora, in the depths of the Vladimir countryside on the steep bank of the Koloksha river. But two of them had been saved by some resourceful peasant, some pious or acquisitive village woman. The Ascension and the Bogolyubov Virgin were still preserved 'in the houses of peasants belonging to the parish' – a hundred and thirty years ago. This might be a long time for an ordinary icon to be preserved in a village hut, but they would have taken special care of these ones rescued from the flames, and treated them with special honour. A mother, on her death-bed, would charge her daughter not to throw them away, and the daughter, when her own time came, would commend them to her children . . .

My grandfather, Aleksey Dmitrievich, was born in 1849 and died in 1933. His father, my great-grandfather, may have been born in 1820 or even 1810 – so the fire at Prechistaya Gora was in the days of our great-grandparents. That was not so very long ago – and supposing I were to go now to the village and question as many people as I could . . . Suddenly I felt breathless with excitement.

The idea that I might actually handle a fragment of such antiquity – begrimed with soot and wax drippings, but real and tangible – occupied my thoughts to the exclusion of all else. Human nature is such that we can be wholly absorbed by anything in the style of a detective quest, anything that involves getting on the track of a fact or an object . . . A few

pages further on, my 'Descriptive Guide' presented another alluring problem. In the passage on Cherkutino village and adjacent hamlets there was a footnote in small type which said: 'In a chapel in the hamlet of Goryamino there is a very ancient icon of Saints Boris and Gleb.'

At the time when I first took up the quest for icons there was a young artist living in our village, a graduate of the Cinematograph Institute called Yevgeny Ignatyev. His aunt Polya, with whom he lived, called him by the pet-name Zhenyushka, and so did everyone else. He was collecting material in the village for his diploma, and went about with a sketchbook painting water-colour landscapes or portraits of villagers. This left him plenty of spare time, and we used to meet for long talks. Since I could think of nothing else in those days but old icons, we usually talked about them . . . I read him the passage about the two shrines, the one that had burnt down in the 1830s and the other that was still standing in 1893, when my guidebook was published. Like two marshals before a battle, we began to plan our expedition.

We discussed which objective to attack first. On the face of it, the arguments seemed to be in favour of Goryamino. In the first place, it was nearer – only two miles away, while Prechistaya Gora was more like eight. Secondly, it was closer in time. The icons at Prechistaya Gora had been rescued from the fire a hundred and thirty years ago, but the Boris and Gleb icons were still in the shrine at Goryamino in the 1890s. Thirdly, their location was more precise: a specific shrine, not 'houses of peasants belonging to the parish' . . . Nevertheless, if one thought again, none of these arguments was conclusive. Two miles or eight miles amount to the same thing in a car. A hundred and thirty years is more than seventy, but there was no crucial difference here: both dates belonged to pre-revolutionary times, and more things may happen in a single year

than in the whole preceding century. Thirdly, the location was not all that more precise, and it might even be easier to discover an old blackened board in a peasant home than in a derelict chapel.

We argued the matter back and forth for some time, till Zhenyushka exclaimed: 'Why are we wasting time like this, it's only two miles anyway. We can be there in a minute or two and see for ourselves. Come on, let's start!'

Thus our first expedition – later we came to call them salvaging or rescue operations – was launched. As we drove along, we agreed that the Goryamino shrine would almost certainly have disappeared, swept away by the cataclysm – unique in the world's history – which had overturned and engulfed palaces, temples, families, social classes and whole nations, in fact everything and everybody on Russian soil. How could we expect, after such a tempest, to find an insignificant bit of wood, with the images of Boris and Gleb smeared with candle-grease and lamp-black? Was there any place, even in the very depths of the ocean, where the waters had not been stirred up and troubled by that fearsome hurricane? No, there could not be, and we were sure to find that the shrine at Goryamino had been destroyed. Yet even if it had, there must be people at Goryamino who had witnessed its destruction and could tell us about it.

Goryamino lies on a steep slope, at the foot of which is a meadow and a stream called the Vorshcha. We entered the village from above, braking as we drove down the main street. I did not want to leave the car on such a slope, and looked out for a lane into which we could turn. I soon found one, and we stopped on a grassy verge beside a woman who was washing clothes: she wore an apron, and was soaping a large garment in a zinc trough that rested on a stool.

It was our first expedition, and we did not quite know how

to set about things. We began in what seemed the obvious way.

'Good day to you.'

'Good day, if you're not joking.'

'Of course not – why should we be? Do you mind if we leave our car outside your house for twenty minutes or so?'

'Leave it till Christmas if you like. I suppose you're on some Party business? Are you from the area or the district centre?'

'No, we're here on our own account. We're interested in old things. I've heard this is an ancient village, an historical sort of place?'

'Yes, that's true enough. It's an older place than Cherkutino – you know, that big village not far away?'

'Yes, we know it. Speransky* was born there, wasn't he? But what's Goryamino famous for?'

'The old folk say that this used to be the main village and Cherkutino was a hamlet belonging to the parish. But that was ages ago – the old people don't remember it themselves, it's what their grandfathers told them. Then Cherkutino got rich, and the people there took over the parish church – that's how their village got its name.'

'I don't understand.'

'Well, in the old days the word for "church" was "cherkva", so it got called Cherkvatino and then Cherkutino.'

All this was clear enough, and I had read the same explanation of the name in an old book about Speransky.

'Yes, I see now why it's Cherkutino, but why Goryamino?'

'Because of "gorye" meaning grief – our people were grieved when they took the church away from us.'

'You don't think it's from "gora", a mountain? Look at this steep slope. Mightn't that be the reason?'

She thought for a moment and then said decidedly:

* Famous Russian statesman in the reign of Alexander I.

'No, my young friends, don't you try to confuse us. It's from "gorye", not "gora". That's what the old folk have told us and that's what we believe.'

'All right, we won't argue with you. But how do you know there used to be a church here? There ought to be some trace of it, a shrine for instance.'

She smiled. 'Yes, I can tell you about that. It used to be just here in front of my windows.'

'How long ago was it pulled down?' I asked as calmly as I could.

'Two years ago. They brought a tractor from the state farm and rammed it into the shrine, which fell to pieces. Then they took it away for firewood.'

'What did they want to pull it down for?' The woman looked blank. 'I mean, they must have had some reason. If the tractor driver was drunk and ran into it, of course, that'd be different, but . . .'

'I don't know. They pulled it down, that's all. I suppose they knew what they were doing.'

I feared that the conversation, after getting off to a good start, would lose itself in generalities; so I reverted to the narrow, but specific theme that concerned us.

'Well, never mind – if they pulled it down, they must have had some good reason. But weren't there any old things left in the shrine – lamps, hangings, ornaments of any kind, or those – what do you call them – icons?'

'The icons had all gone long ago. So had everything else. There was nothing left but the outside.'

'But the things can't have all just vanished into thin air. Didn't the villagers share out the icons and take them home?'

'No, I can't remember anyone taking them home. To tell the truth I don't know what happened to them. Anyway it was all stripped bare, there was nothing left.'

Then she paused and, as if she had read our thoughts and knew exactly why we had come, said in a distinct tone:

'Only one single icon was saved from the shrine, and that was the one of Boris and Gleb. My neighbour Anna Dmit-rievna has it hanging up in her house. That's all that was left, and it's a long time ago . . . Just one single icon.'

To any unconcerned listener, the words 'Boris and Gleb' would not have sounded in any way special. They were spoken no more loudly or quietly, no more or less distinctly that the rest of the sentence in the woman's even tones. But to us they were like an explosion, a shaft of light, a bolt from the blue. Zhenyushka's lower jaw dropped open as if he had been struck with the palsy.

'Do you think we could see that icon, the Boris and Gleb one?'

'No, she wouldn't show it to you. She's a crotchety old thing, doesn't like strangers. Anyway she's in a bad state just now – you may have heard about the young chap who was buried the other day, the tractor driver. It was her grand-son.'

Yes, we had heard about him. The lad had spent the day drinking himself silly, and when evening came he felt, as one does, that he wanted more. But the shops were shut and there were no drinking places, so he went to the store in the next village. I had better explain what that is. The shops in the larger villages or at the headquarters of state and collective farms also cater for neighbouring hamlets through a system whereby housewives buy goods at the shop, take them home and sell them there. They are not saleswomen by profession but ordinary farm workers who spend the day digging potatoes, milking cows, carting hay and so on; but in the evening or even late at night people can go to their houses, get them out of bed if necessary and buy anything they need. Did I say 'any-

thing'? Well, strictly speaking they don't sell everything, but they do sell one thing that people are apt to need after work and at times when the ordinary shops are shut. Not to put too fine a point on it, the only thing they sell is vodka.

So this drunken youth drove along on his tractor to the nearest hamlet in search of one of the 'home workers', as they call them. It was a dark, drizzly night, and the tractor skidded down the steep slope into the river. The boy's legs were caught and he was drowned at the wheel, or he may even have been killed as the tractor was tumbling downhill. For days afterwards all the local villagers were talking about the story, and we had heard it several times. It had not occurred to us that it might directly concern us, but now it turned out that the dead youth was Anna Dmitrievna's grandson, that it was she who possessed the ancient icon of Saints Boris and Gleb and that the accident might thus have a decisive effect on the success of our enterprise.

It would be an understatement to say that we were thunderstruck by what the woman told us about the icon. To conceal our excitement we hastily moved away from her house and Anna Dmitrievna's and sat in the middle of the village street, discussing feverishly what to do next. The villagers, full of curiosity, looked at us through their windows.

We had good reason to be excited. We knew that the icon was there in Anna Dmitrievna's cottage, but we also knew that it would be no easy matter to get her to part with it, in fact she would most likely refuse. This seemed to us a crying injustice. Here were we in our collector's fever, we had read in our book about the shrine at Goryamino, we had followed the scent and tracked it down. Our most passionate desire was now to obtain the icon, and we were able and willing to pay for it – but, without knowing for certain, we already suspected that in dealing with an old woman of this sort, money was the least

effective argument we could use, if it did not actually defeat our purpose.

The fact that the icon represented Saints Boris and Gleb aroused our excitement still further. Christianity had come to Russia bringing its own sacred personages: Christ and His Mother, St John the Baptist, St Nicholas and St George, the apostles and prophets and many other saints. Then, as time went on, our own Russian saints had begun to be canonised, and the very first of these were Boris and Gleb, the young sons of Prince Vladimir of Kiev, who were treacherously slain in the course of an internecine struggle. They are always depicted together, either standing or on horseback, carrying swords and wearing ermine caps. Sometimes Prince Vladimir is shown between them. As every collector knows, an icon of Boris and Gleb is a great rarity, and to begin our collection with one, and an ancient one at that, would have been a triumph indeed.

'Would have been' – why, it already was! The icon was a mere fifty yards away; but first we had to cope with the character and willpower of Anna Dmitrievna. She must have known what she was about when she took home that single icon from the shrine. At this very moment, no doubt, she was praying to Boris and Gleb for the soul of her grandson. The icon was the most precious object left to her in life – how could we hope to persuade her to let us take it away for ever?

As we walked up the steps in front of the cottage, I had a clear presentiment that the icon was not to be ours. Anna Dmitrievna appeared: she was an old, bony woman, dressed in black. She sat on a stool facing us.

'I haven't seen you before, have I? My eyes aren't too good: one of them's quite blind, and the other's going the same way. What have you come about?'

'You know, Anna Dmitrievna, my mother has trouble with her eyes too. She gets some special drops from Moscow and

uses them every two hours, otherwise she'd have been blind long ago. If you like, I could get a phial of the drops and bring it to you.'

'I don't know, I'm sure. Why do you want to put yourself out for me? I kept meaning to write to Stepanida Ivanovna at Olepino: they say she has trouble with her eyes. And she's got children in Moscow, one of them's a writer. I expect she must have some cure for them.'

'Do you mean to say you know Stepanida Ivanovna?'

'Why, of course I do. We were great friends in the old days. And I knew her husband well, Aleksey Alekseyevich. We used to visit them at harvest-time . . .'

It was true, we used to have lots of visitors in the old days. After Mass and before they all went back to their own villages, they would come along the path that led from the church to our house. There they would stand on the threshold, fervently crossing themselves, all dressed in their Sunday black, with black lace kerchiefs; and then they would all sit round the table where the big samovar was boiling . . .

'Anna Dmitrievna, I expect you don't recognise me, but I'm the younger son of Aleksey Alekseyevich and Stepanida Ivanovna.'

She gave a start of surprise. 'Fancy me not recognising you! But I can't see a thing – one of my eyes is quite blind, and the other's going the same way. No, I didn't recognise you, and that's a fact. Let me put on the samovar – I'll have it on the boil in no time.'

We ought to have said yes – for there is no better way of getting on good terms than by sitting together listening to the cheerful, unhurried note of the samovar. One might well spend a day, or three days for that matter, drinking tea convivially, but we did not have the patience of proper hunters, and we politely refused the old woman's invitation. Neverthe-

less the conversation became more animated, and we even worked it round to the question of the shrine.

'It was two years ago they knocked it down,' said Anna Dmitrievna with unconcealed hostility towards 'them'. 'They sent a tractor from the state farm and smashed it into smithereens.'

'But what became of the things inside? There must have been lamps and censers, and those boards with paintings on them.'

'No, there was nothing left at all. Not a single icon left for the village to remember the shrine by.'

She stopped and smiled as if at a secret memory, and, after what seemed a very long pause, went on:

'Well, but I have one icon that used to belong to the shrine. It's one of Boris and Gleb. Not a big one, it's true, and nothing much to look at – no metal ornament either, just the plain board.'

'If it's nothing much to look at, why did you take that one?'

'Because it's not an ordinary icon, it's a special one, revealed by God. Everyone in the village paid great honour to it, and I offered to be the one to keep it. You can look at it if you like. You mustn't touch it, but you're welcome to look.'

Anna Dmitrievna took us into her storeroom. The windows were shuttered, but in spite of the dark I saw the icon at once, hanging in the far left-hand corner. When she took down the shutters there was nothing else to be seen but bare, yellowish timbered walls. We stood in front of the icon and looked at it.

It was painted on a more or less square panel, measuring about twenty inches each way. There were Boris and Gleb, both wearing caps and carrying swords. Zhenyushka was behind me, and I could not even hear his breathing. From the very first instant, although I knew hardly anything, or rather nothing whatsoever, about icons in those days, I could see that far from this being an 'ancient' specimen it must have been

painted some time in the twentieth century. To be sure, it was possible that, being an object of especial veneration, it had been restored; and of course before the Revolution, some fifty or sixty years ago. But why was the picture not recessed, and why did it look so fresh and new, as if it had not hung for four hundred years in a shrine at Goryamino, but had just come out of a workshop?

'Anna Dmitrievna, I don't understand. The Boris and Gleb icon is supposed to be a very old one, but the painting on this is quite new. Has it been put here instead of the real one?'

The old woman smiled. 'This icon meant a lot to us, we paid it great honour. And what happened was this: when the shrine burnt down, all the icons burnt with it, Boris and Gleb as well as the others. So I sent my husband to Moscow and said to him, "You find a good painter to make a new Boris and Gleb for us." Everyone in the village gave some money, and off he went. That icon there is the one he brought back. We had it consecrated and held a proper service when it was put back in the shrine.'

'But you said the shrine was burnt down.'

'Yes, but the men made a new one.'

'When was the old one burnt?'

'On Easter Sunday, it was. We were drinking tea, and there was a kind of flickering light outside. I looked out and – heavens above, the shrine was burning! A candle must have fallen over, and with all that dry wood and paint it burnt to a cinder – nobody saw it in time. The Boris and Gleb icon was the holiest of all, but we couldn't rescue it.'

'And when was this?'

'I told you, on Easter Day. We'd just sat down to have some tea . . .'

'I mean in what year?'

'Ah, that I don't remember. I was married, I know, because

it was after that we sent to Moscow to the painter. And I remember it was after our children were born. It must have been about 1910, I suppose.'

I was gratified at having guessed the date so accurately, but I would rather have been mistaken.

'Do you remember if it was a new icon your husband brought back or an old one that had been in a church already?'

'It wasn't an old one – I should think not! Why, he paid a lot of money for it – fifty roubles, it was a great deal in those days. And then we had it consecrated, and everything.'

'Did the old one look like this, or have you forgotten?'

'No, I remember it very well. Yes, it was sort of like this one. Boris and Gleb, just the same. But their faces were smaller and the figures more old-fashioned. All just the same, but a different kind of painting. And the same kind of board, too . . . You know, a different style.'

As we left Goryamino we did not know whether to be sorry or glad. It was, of course, frightful in any case that an ancient icon of Boris and Gleb had been destroyed in 1910 together with the shrine – an irreparable loss, and one could only grieve at it. But as far as the present day was concerned, we could not decide whether it was better to leave Goryamino knowing that Anna Dmitrievna possessed a fifty-year-old counterfeit, or whether we would have preferred it to be an antique of immeasurable value that we were allowed to look at but not touch.

I remember clearly enough that at the time I felt a kind of relief, due to my selfishness as a collector. But as time passes I feel increasing regret that the icon was lost and can never be replaced. For there have never yet been, in the whole of Russia, two icons exactly alike in painting.

6

FOR OUR first quest, then, we had chosen Goryamino as a destination and not Prechistaya Gora; but there was nothing now to prevent our concentrating on the latter. Despite the fiasco at Goryamino our experience there had filled us with hope, since all we had had to do was to stop the first woman we came across and ask her where there was an old icon to be seen. With any luck the same thing would happen at Prechistaya Gora – we would come along, ask our question, find the icon and do our best to buy it.

When our forefathers chose the sites of Russian villages and hamlets, they did so with an eye for beauty as well as convenience. Each village has its own charm of position and layout, but few are so attractive and pleasant as Prechistaya Gora. This, to be sure, is no longer its official name. The reason is that across a ravine from it was a larger village named Kobelikha, and as this was thought to be an ugly name the two together were re-christened Krasnoye Porechye. As the new name implies, there is a river nearby: the quiet, clear waters of the Koloksha glide through broad meadows that are alternately green and bright with many-coloured flowers. At one time there were mills and dams in many places; the mills have been destroyed, but something of the old appearance remains, though there is less water and more sedge and water-lilies. Above the river and meadows there rises a large hill, cut through by a ravine like a loaf of bread cut by a knife, and on either side of the ravine are the villages of Kobelikha and Prechistaya Gora, now named Krasnoye Porechye.

It is both a beautiful and a blissful place – there was a monas-
tery on the hill in ancient times, for the builders of monasteries
and convents, as we know, were blessed with taste or at any
rate imagination, and they chose the most attractive and
pleasant sites they could find. They sought after beauty in
order that pious folk should want to visit these sites and should
be touched by grace while they were there, so that after they
went away they would remember them, describe them to
others and sing their praises.

It would have been interesting to see the hill in the days when
it was dominated by the ancient monastery of the Intercession.
Instead, as we approached it, we only saw the elegant white
curve of the road as it twisted to and fro, ascending the green
hillside. When we got to the top we found a large village
divided in two by a stretch of road churned up by vans and
tractors. As we bumped along its surface we guessed that there
must be at least seventy houses in the village.

We were at a loss how to begin. The simplest course, no
doubt, was to go from house to house and ask everyone in turn
whether they happened to have an old icon preserved from
some monastery or other and rescued from the fire a hundred
and thirty years ago. But after some thought we rejected this
plan. In the first place we would not be able to get into all the
homes: the whole village was out at work, and some of the
houses would be empty. Secondly, if we went about pro-
claiming that we were looking for an old icon, the inhabitants
of Prechistaya Gora would start to take an interest in it.
Thirdly, the atmosphere of modern villages is such, or so we
felt, that there would be something foolish and awkward in
going around the houses and asking about icons.

In those days we were shy and naïve and suffered from self-
consciousness, which continued to do us much harm for a long
time afterwards. Anyway, we decided to find the foreman of

the collective farm and tell him that we two, a painter and a writer, were interested in the traditional peasant way of life, or rather what remained of it. I, the writer, wished to observe quietly, and my friend the painter wanted to draw what he saw. We were interested in all the old implements such as sickles, flails, bast-baskets, objects woven from birch bark, embroidered cloths, wooden pitchers – in fact, any old unwanted stuff that might be lying about in attics or store-rooms. On this pretext we reckoned that it would be easy to enter any house we pleased.

The foreman proved to be at the other end of the village, by the threshing-floor, where preparations were being made to gather in the harvest. Again we felt awkward: all the farm workers were busy at various jobs, sweeping and levelling the floor, lining up sorters and winnowing-machines and so forth under the foreman's direction, and here we had come to interrupt the work and chatter to him, in the midst of all this up-to-date machinery, about flails and bast sandals . . .

The foreman, a middle-aged man with a slight limp, walked away from the threshing-floor and listened with attention to what we had to say. Luckily for us, it turned out that the noon-day break was just beginning. He was glad enough to help us though he turned down our plan of going round the whole village house by house. He did not, of course, know our real purpose, but told us how we could best manage to see the things we had asked about.

'The homes here are all different. In some there'll be nothing but a birch broom by the doorstep, and in others they may have a trunk full of stuff belonging to their great-grandmother's dowry. There's one old chap who used to have a big household, where they did all their own work on the premises – a regular old-fashioned set-up. We'll start with him.'

We decided to put ourselves in the foreman's hands and see what Fate provided. The old-timer's house looked just like all the others in Prechistaya Gora: a single-storied brick building with three windows looking on to the street. The old man was short of stature, dried-up but tough-looking, with a grey beard yellowed in places by tobacco stains.

'You have had the right idea. In another ten years there won't be a flail or a sickle to be seen in the village, not one. At least the young people ought to know that they existed once upon a time.'

He rummaged under the eaves and produced a fine sickle, dull from lack of use, which we accepted with some embarrassment. We could have found one in our own village without needing to drive eight miles for it.

Next he fished out a kind of satchel with a flap, woven from birch bark. 'Here you are – the shepherds used these to carry food in.' We moved to a glass-fronted cupboard, from which he took an elaborate salt-cellar woven from the roots of pine-trees. He sprinkled some salt from it on to a newspaper, and presented the object to us with the words: 'Something else for your collection.' The pile of curiosities grew larger and larger as he produced, one after the other, articles made of pine-bark. Not everyone, perhaps, may have seen pines growing on a sandy or clayey slope, and noticed the long brown roots that hang down from them. Some are as thin as twine, others as thick as a stout rope. When we were children, if we wanted to climb a slope we would catch hold of these strong elastic roots and pull ourselves up by them. You could cut one off and use it as a whip, or you could use a thin one as a belt, but it had never occurred to us that they could be woven together to make so many handsome objects. The old man showed us baskets and measures of all kinds, a chest with a lid, a sugar-container that looked like a vase.

'Who made all these? And how do you manage with roots of different thicknesses?'

'My father used to make them, and I learnt from him. I'll show you how we did it . . .' What they did, it appeared, was to scrape the bark off the roots and then split them lengthwise into four, five or eight strands. Thus they produced elastic strips of uniform thickness which could be used to make either a small salt-cellar or a large chest. The strands were clean, white, even and densely woven; with time they had yellowed to the colour of the beams inside the warm cottage.

While we were talking, the news that 'they're looking for old things' had spread round the village. We were dragged from one house to another and shown some antique object in each. We piled them all into the car, driving slowly along the row of houses. We were offered parts of a hand-loom, or even a whole one that was said to be lying, dismantled, in someone's attic, but we declined it. Among the objects we acquired were hackles for spinning tow: they were dark yellow, made of strong shiny wood, more like bone. In one home we were presented with a charming little bell of the kind that used to be hung on the yoke of a carriage-horse: inside it had an iron ring attached to a strap, and around the rim was written in ornate lettering 'a gift from Valday'. When I lifted the bell and shook it, the air filled with a peal so loud that one could not bear it at close quarters. It was made to be heard from a distance, across fields and woods, or when a troika or a single horse drawing a sleigh or springless carriage turned from a lane into the main highway. When people who had just said goodbye to their loved ones heard the sound growing gradually fainter it made them sad; to those awaiting guests it brought joy as it suddenly became audible in the distance.

They also offered us another kind of bell – a magnificent copper globe about the size of a large apple, with slits cut in it

crosswise, and inside it a metal pellet about the size of a hazel-nut. The globe was suspended on a loop attached to a strap decorated with small copper plaques that had gone green with age.

One woman produced a green-glazed earthenware *kvas*-jug shaped like a pig, of an almost abstract design. We also acquired some round carving-boards – they had been turned on lathes and looked like thick plates resting on low supports. Some of them were actually worn through – they must have been used throughout the year, and not just at Christmas or harvest-time, to carve fat roast beef or mutton on.

Then we were offered a wooden trough in which meat used to be chopped up to make galantine – a handsome affair with thick sides and bottom. It was cracked and no longer usable, but this made it look all the more fascinating as an antique.

Perhaps the two finest pieces in our unexpected collection were two wooden ladles. The hardest to lug to the car were a set of round metal weights, ranging from one pound to about five stone. Then there were a number of shepherds' salt-cellars, which had been designed for outdoor use. I had never seen one woven from birch bark before. It was something like an oblong water-bottle, smaller and flatter of course, and with the opening not in the middle but at one corner; it was rather like a child's first drawing of a locomotive, that is to say a plain rectangular shape with a funnel sticking up at one end.

There was also a birch-bark pencil-case that some father had made for his small son, with a naïve but quite expressive design along the side. There were cases for whetstones made of the same material and a genuine shepherd's horn made of boxwood – for it turned out that a craftsman living at Prechistaya Gora had made these for the whole province in the typical local style.

As our collection grew it came to include a few blackened

icons that had been fished out of someone's storeroom or attic. One was split in two, the paint was flaking off another, another consisted merely of a coloured print pasted on to a board. At this stage we were not so much concerned actually to acquire icons as to talk about them and to induce as many villagers as possible to take part in the conversation. We did our best to steer it in the desired direction, but no one said a word about two icons that had been in a shrine belonging to the local monastery, had been saved from fire and were preserved somewhere in the parish. One young man, however, had in the 'front corner' of his cottage a large icon resplendent with blue and gold: when the church was destroyed, he had been quick to lay hands on the showiest object in it.

'You rescued the wrong one,' we told him. 'You should have chosen dark ones where there is nothing to be seen except the faintest glimmer of a pattern. Weren't there some in the church like that?'

'You mean to say you're looking for that kind? Are the old ones really the best? – Hold on, fellows!' he cried out to the others in the cottage (although some were women and children). 'Hold on – I remember, when I was quite small, I heard about someone keeping a very old monastery icon – I don't remember what icon or what monastery, but they were talking about it all right.'

I tried to keep my voice from trembling; I succeeded in not dropping the cracked earthenware pot, enclosed in wickerwork, that the young man's neighbour was at that moment pressing on me.

'Can you remember who it was that had it?'

'No, I can't. But some of the men here might remember, they're older than me. Can't some of you remember? – it was here, in Prechistaya Gora, that they were talking about it.'

'That's true, someone did keep an icon from the old monas-

tery. But whoever could it have been now? Was it the Za-kharovs, maybe?'

'That's right – I remember now, it was the Zakharovs.'

'That's who had it all right. They had icons all over their walls, they were a pious lot.'

'Why do you keep saying they *had*? Are none of them left?'

'There's only an old woman left, and now the young ones have taken over. I don't expect there are any icons now. They had a fire at their place, and the storeroom burnt down as well.'

'Maybe some of the things were saved?'

'Maybe they were. They live over there where the church used to be – you can see the house through the window, that brick one with the green roof and the little garden.'

Zhenyushka and I walked off to the Zakharovs' house in a high state of excitement. Here was a clue to something very ancient which ought long ago to have disappeared in the flames of revolution or a village fire, or been swept away in the whirl-wind of collectivisation, or simply been lost in the normal course of time – but here we were, hot on its trail, having stumbled on it by the merest chance. Perhaps the thread that had just come into our hands was all we should ever see of it – perhaps we should discover nothing more than a scrap of what we were seeking, a square inch or two of wood, but at any rate we had hold of the thread, and nothing could stop us following it to the red-brick house with the green roof.

When you enter a peasant house the custom is not to knock but to step in, saying in a loud voice 'Is anybody there?' There will then be signs of life, and someone will come towards you or shout 'We're at home, come through here.' So on this occasion we asked 'Is anyone about?', but received no answer. We walked through the kitchen to the living-room and still saw no one. The only other place was behind a screen, where

there was a bed half-hidden in darkness, and on it a bony old woman who sat covering her head with her hands, as though embarrassed. The reason soon became clear. She had come back from hospital the previous day, and there they had shaved off all her hair. She was ashamed of her bald head, and had not had time to cover it with a kerchief. She sat there covering the indecent spectacle with her hands and trying not to look at us. We did out best to put her at her ease: I found a kerchief hanging on a nail on the screen, handed it to her and she put it on, after which we were able to tell her what we had come for. We noticed with surprise that she did not talk like a village woman but as if she had lived in towns and read quite a lot; she might even have been a village teacher in her time.

'Yes, we used to keep a great many icons at home. The best ones were in the "front corner", with lamps burning in front of them and with the usual metal overlay; and then we had some in the storeroom too.'

'What about the icon of the Resurrection that used to be in the monastery?'

'Yes, we had that too. My grandfather used to say that it had been in a shrine which had burnt down.'

'That's right, that's the Resurrection we want to know about.'

'Well, I'm telling you. We kept it after the fire, with the other icons in the storeroom, because the metal overlays had got lost.'

'May we go and look at it?'

'There's nothing to see now – no storeroom and no icons. We had a fire, and everything was destroyed.'

'The Resurrection as well?'

'No, not the Resurrection. God preserved that.'

'You mean you rescued it from the fire?'

'No, it happened differently. A month before the fire our

village priest, Father Aleksey, came to see us and said: "I have heard that under this roof there is an ancient image depicting the Resurrection of our Lord and Saviour Jesus Christ. It should be kept in the house of God, so that all those of the parish may see it and address their prayers to it, and may thus receive the Lord's blessing." In other words, he wanted the icon for the church, and of course we agreed. So it was solemnly carried out of the house in a procession with prayers, and in the church they put flowers round it and held another service, and there it stayed.'

'And what happened afterwards?'

'Afterwards the church was closed and the icons smashed up and burnt – that one too, most probably. I don't see how it could have escaped.'

If only the youth who told us about the Zakharovs had had the sense to take the Resurrection instead of the blue and gold icon!

'Do you think,' we said to the old woman, 'that one of the parishioners may have taken the Resurrection at the time the church was closed? It was a very special icon, with all those flowers and prayers – mightn't someone have rescued it?'

'I dare say they might. God wouldn't have saved it from the fire in our house just to let it be destroyed with the church. Perhaps it was preserved after all, but I never heard so. If anybody, it might have been the churchwarden's wife – but she doesn't live here now, she moved to Zagorsk or Kirzhach or somewhere. She might have taken it, I really don't know. Anyone might have, it's a big village. But I never heard of it happening, never a word.'

'I suppose you remember what it looked like, the size of the picture and what was in it exactly?'

'I don't remember for sure. It was a cheerful picture, with lots of bright colours: the Resurrection, the greatest feast of all.'

'Yes, it's a great pity. Such a valuable icon, going back into the dark mists of time.'

'How do you tell between light and darkness? When there was a monastery and a church here, and we used to decorate the icon with flowers – do you think the village was a darker place then? You're mistaken, my young friends. The icon came down to us from the bright days of antiquity, and now, as you can see, it's been swallowed up by the darkness of ignorance. And here are you two young men looking for it – why? Because the icon is a light and a flame, drawing you to itself.'

She spoke quietly, with a faint smile at the corners of her lips as she watched the disconcerting effect of her words upon us . . . We walked back to the car in perplexity. We might have continued the search, but for some reason we felt tired. An old fellow cried as we passed: 'What about a farm-cart, young men? I've got one at the back here – it used to belong to a man who farmed on his own.'

'No, no, we don't want a cart.'

'Then what about some pitchers? I've got some in the basement that they used in the first German war – the vets kept ointment for horses in them. I've no use for them now – you could have them at a rouble apiece.'

'All right, let's see what they look like.'

He produced three jars. The first was round in shape, with a tiny handle, just like a thirty-six-pound weight. The other two were handsome, like Greek amphorae, made of black, shiny earthenware with ornamentation. They smelt horrible, and if we did take them we would certainly have to soak them in kerosene: the 1914–18 ointment had caked into a solid mass. I later saw similar jars in the folk art museum in Stanislavsky Street, but these were more artistic and better preserved. They told me at the museum that the ceramic technique in question is known as 'black gloss': it was very complicated and is now

virtually lost. So I am not sorry that we took the old man's three stinking jars and loaded them into the car, although at the time it seemed to me that we had got rather more than we bargained for. When we had left the village and were driving through the forest I even said to the others: 'Well, shall we get rid of all this junk now or wait till we get home?' and my wife replied:

'We'll do no such thing. We'll wash and clean and tidy it all, and get more things of the same sort, and one of these days we'll have a folk art museum of our own.'

'Heavens, are we already at the museum stage?'

'No, not yet. But don't you see that we've got the makings of one?'

Perhaps we had. But I could not forget the vision of the Resurrection icon with its bright colours, now lost to view or even destroyed, as the old woman had put it, by the darkness of ignorance, but which, if she was right, would continue to beckon like a flickering flame.

7

NEVER before in my life had I experienced such a strong, such an overmastering passion. Not only did I neglect my work and spend days on end reading the 'Descriptive Guide' as a prelude to new forays into the countryside; not only did I spend sleepless nights wondering where else I could look for icons, but they even pursued me in my dreams. Instead of quiet visions of fishing trips or childhood memories, all I saw was black boards with the paint scaling off, cleats, and the faces of saints glimmering through the dark linseed-oil.

In one of my sleepless nights it occurred to me that I was being far too casual in my search. When I first read the account of Prechistaya Gora I had paid attention only to the two monastery icons that had been kept in the shrine and escaped the fire. But in the very next sentence it said: 'An icon of the Mother of God from this convent is now in the village church at Yeltesunovo.'

The moment I remembered this I jumped out of bed and opened the book. Yeltesunovo, page 118 – yes . . . 'Thirty-five versts from Vladimir, on the estate of Orina Nikitichna . . . The present church is of stone; it is not known by whom or when it was built.' Then, further on, the vital words: 'Among the holy icons, an especial object of popular devotion is the Galitsky icon of the Mother of God, to which the villagers attribute their preservation from the cholera epidemic in 1848.'

Could there be any doubt that the two Yeltesunovo icons were one and the same? The Mother of God icon that found

its way after the dissolution of the monastery to the church at Yeltesunovo was the most ancient in that church and became the most venerated. Moreover, it was not simply added to the icons hanging in the church, but 'appeared' there. This was understandable. The people of Yeltesunovo knew their own icons individually and prayed to them, so there could be no question of any one of these 'appearing' or suddenly manifesting itself or its power, as a completely new icon might do.

I drove to Yeltesunovo, left my car on the outskirts of the village and went on foot to look at the ruins of the church. There were still traces of blue on the interior walls. It seemed as though a heavy shell had been fired through the building, after which tanks had gone through it, and now the wind was blowing freely through what was left. The bell-tower, which had been a landmark for miles around, had disappeared without trace. In former days travellers had been able to stop and count all the neighbouring villages nestling among fields and woodland: Rozhdestvenno, Ratmirovo, Fetinino, Kichleyevo and finally Yeltesunovo. From the outskirts of Vasilyevo they could discern, in the golden-blue haze, twenty-one white belfries thanks to which they were able to take their bearings. In winter, during snowstorms the bells were always rung, performing the function of a lighthouse. And those who passed by could simply admire them, since they were the glory of the undulating Russian countryside, while from the towers themselves you could admire the vast expanse of the Russian land.

After standing for a while in front of the ruined church, I walked about the village and then sat on a bench near a peasant's house. Soon after, a man came along and sat beside me; then two women, and some children who appeared from nowhere. I began the conversation, of course, by commiserating with them about the church, and then said:

'Wasn't there some very well-known icon in the church, a specially old or beautiful one?'

'I should think there was indeed,' said one of the women. 'The Galitsky Mother of God – a wonder-working icon.'

'Where had it come from?'

'No one knew. It just appeared. It was at a time when people were dying like flies from the cholera. Before our day, of course, but the old folk have told us about it. All of a sudden it turned up in the church loft. How the icon got there, and how long ago, nobody knew, but it appeared just at the time of the cholera.'

'And what happened?'

'How do you mean, what happened? They had a special service and carried the icon round the church and the village, and then it was hung in the church. Everybody knew it as the Galitsky Mother of God, the icon revealed by Our Lord Himself. And so the cholera stopped, and it was declared to be a wonder-working icon.'

'What happened later on?'

'When the church was closed they took a lot of the icons away to Olepino and made tables out of them by just planing down the top and sticking on four legs. Any that were left, the schoolteacher took for firewood. He asked everyone in the village, anyone who liked, to go to his backyard and watch what he did with them. Not everyone went, but some of us did. He stood the icons in a row, took a chopper, spat on his hands and we thought he was going to let fly at them all . . . But he put the Wonder-Working Virgin to one side for some reason, whether on purpose I don't know . . . Anyway, that was all a long time ago . . .'

'And do you know of any icons now that are in people's houses?'

'You see the place with the blue roof over there – it's the home of two sisters. One's an old maid and the other used to be a nun. Their walls are fairly plastered with icons. Other people may have two or three, but nothing like the same number – that place is full of them.'

I called on the two sisters, but made rather a mess of the visit. I should of course have greeted them in a leisurely way, sat down for a talk and got to know them properly. Then they might have shown me everything they had, but unfortunately I was too impatient.

I began decorously enough, and would have gone on in the same way if it had not been for the profusion of icons in the 'front corner'. The silver and copper overlays were polished so that they shone; all over the place there were flowers – real ones or made of wax; a china dove hung in front of each halo, and until I saw the flicker of light I did not at first realise that they were lamps. The whole corner was covered with icons from floor to ceiling as though to make an iconostasis. I could not take my eyes off them, nor could I concentrate on the conversation. Instead of looking at the two sisters I was gazing at the icons. Among those adorned with overlays and metal haloes I could see part of a black board, about as big as an open exercise-book: this intrigued me, and in the middle of some conventional remark I got up and walked, as if hypnotised, over to the iconostasis in the corner. The board was on a shelf about two inches from the floor: I bent down and stretched out a hand to take hold of it and inspect it in the light. I could just see, through the blackness, that the whole surface was occupied by a picture of the Virgin with huge mournful eyes. I had almost touched it when it was snatched from before my eyes by the ex-nun, who had darted in sideways like a sparrow-hawk and, with the rapidity and skill of a conjuror, concealed the precious object under her white-spotted black apron. Her eyes as

78

she did so were full of determination, anger and downright hatred, mixed with fear in case I should try to seize the icon from her.

'Good heavens,' I said, 'I only wanted to look at it.'

'You shan't, you shan't!' she cried in a frenzy. I expected her to start stamping her foot at any moment. 'Haven't you mocked them enough? Are you still not satisfied? Don't I remember how you went at them with axes? You shan't, I tell you! Hit me instead if you like, chop me to bits, throw me into the stove – I won't let you touch it!'

After this outburst she ran out of the hut and did not appear again. Her sister was full of apologies.

'You mustn't be angry with her. She's a very pious, very religious woman. There was no joy in her life but God, so now you see. . . .'

'But why did she hide that broken-off piece and not one of the other icons?'

'Because it has a special history. There used to be a miraculous icon called the Galitsky Mother of God. When they closed the church, the village teacher chopped it up for firewood, and my sister crept into his backyard at night and found the part with the Virgin's face on it, and she's kept it like this ever since. You see, she's not to be blamed really. It was the only consolation of her old age, and when people are no longer young you can't re-educate them.'

'Couldn't you persuade her now to show it to us of her own accord?'

'No, I couldn't. You saw what she's like – you heard the way she feels about it.'

'And is it certain that it was a piece of the Galitsky icon that she picked up in the schoolteacher's yard? She might have made a mistake in the dark.'

'She knew the real one well enough. Anyway, she believes

it's part of the Galitsky one, and that's really all that counts, isn't it?'

As far as the nun was concerned, that might be so, we thought as we took our leave, but to a collector what matters is to have precise information . . . Though in this case it was all the same, since there was no possibility of our laying hands on the mysterious fragment.

8

THE reader will remember our quest for 'Boris and Gleb' at Goryamino. This icon had been in a shrine or chapel on the site formerly occupied by a wooden church. The church, according to our informants at Goryamino, had been transferred to Cherkutino, two miles away. As the shrine was meant to preserve the memory of the church, they would not have bought or commissioned new icons for it: they took the ones from the church itself so that the villagers could pray in their accustomed manner and would thus feel the loss of the church less keenly.

In the course of time, however, as the icons in the shrine deteriorated they were replaced one after the other by new ones, so that eventually the only one of the original series that remained was that of Boris and Gleb, 'remarkable for its antiquity'. The villagers had treasured and revered it, so much so that when it was destroyed by fire they had spent as much as fifty roubles – the value of two cows in those days – on getting a substitute from Moscow.

How many icons from the original church would there have been room for in the shrine? Probably not more than five or ten. The remainder, contemporaries so to speak of Boris and Gleb, would have been taken away to Cherkutino.

The church in that village is mentioned in the year 1628, where it is stated that 'The church of the Wonder-Workers Saints Cosmas and Damian in the village of Cherkutino belonging to the domain of the Grand Duke Mikhail Fedorovich, Tsar of All the Russias, is assessed for one rouble fourteen altyn and two denga.' Consequently the church was trans-

ferred earlier than that date, in the sixteenth century. Thus the icon of Boris and Gleb would also be a sixteenth-century one, as well as the other icons removed from Goryamino to Cherkutino.

It is certain too that the church at Cherkutino was restored several times before being replaced by the brick structure with a bell-tower which stood there until recently – in fact it was still standing when I began my researches, but in 1967 it was razed by order of a certain Krasnoyarov, the manager of the local collective farm. It so happened that at that time three of my friends from Moscow, all writers, were staying with me, and I had taken them to Cherkutino where a car was to pick them up for the return journey. When we arrived we saw the church in ruins: it had been destroyed two days earlier. I was particularly shaken by the appearance of the dome. It had not looked very large in the sky, against a background of scudding clouds, with its proportions appropriate to the rest of the building, but on the ground it looked enormous – large enough to contain a living-room – and at the same time dead, empty, wretched and soulless.

My friends too were shocked by the sight, and exclaimed angrily:

'Disgraceful!'

'He ought to be taken to court.'

'As soon as I get back to Moscow I'll ring up the newspaper and tell them to send a photographer.'

'Better still, I'll ring up Mikhalkov and they can make a film.'

I listened with some scepticism, but I sympathised with their indignation.

The church at Cherkutino had been restored many times over the years, and the same was no doubt true of the church furnishings and icons. There was little hope that any of the

original ones would still be there, yet I did not quite despair either.

In 1798, the guide informed us, a new church was built at Cherkutino, a wooden one on stone foundations. It was situated by the graveyard, on the outskirts of the village, and was dedicated to the Assumption. The brick church completed in 1801, which survived until the Krasnoyarov era, was also under construction in 1798; new icons were commissioned for it, and a place had to be found for the old ones. It would have been natural for these to be transferred to the church by the graveyard. They were on good stout boards that had stood the test of centuries, and for a believer an old icon that has heard many prayers is a more valued object than a new one. It is also cheaper to restore the painting of an old icon than to commission a new one. For the top row of the iconostasis, at any rate, there was no need to run to the expense of new icons; all that was necessary was to restore the painting and affix new copper overlays, and the quiet church by the graveyard would be as well-adorned as could be desired.

I do not know what the graveyard looked like in 1798, when the wooden church was built. Today, if you look at it from a distance – from our own village, for example – it presents the appearance of a high, dark clump of trees – a sort of island standing out of the dark, level area that marks the surrounding village. When the church was built they planted lime-trees around it, and these have grown up so as to hide the wooden building and even the little cross at the top.

Any traveller about Russia, especially in the ancient lands on the upper Volga, is accustomed to the sight of village graveyards that spring into view at the very furthest point of the horizon, from six to ten miles away, among copses and villages with their fruit-trees and white willows. The graveyard stands out among these like a bush in a meadow – in fact, we

83

were once told, when we asked the way somewhere: 'You see that bush? Well, you drive up to it and then turn to the left.' When we reached the 'bush' in question, the trees proved to be about ninety feet high. We even had an argument: one of us thought that graveyard trees grew so high because they stood for decades without being touched by the axe, while the other maintained that they were twice as high as other trees because their roots reached down to the graves below.

At all events, the Cherkutino church was hidden by the graveyard trees, so when we met a village woman on our way there we asked: 'Is the wooden church that used to be by the graveyard still standing?'

She replied with a kind of alarm: 'It must be, surely. It's a long time since I've been over there, but I would have heard if they'd knocked it down. It hasn't been used, though, since 1927: they stripped it all bare inside and only left the building itself. If you go and ask old Nikolay the sexton he'll tell you all about it. He's blind and doesn't go out any more, but he can talk and he still has his wits about him.'

The graveyard was in a large green meadow on the out-skirts of the village. The wooden church was surrounded by graves, lime-trees and lilac bushes, and all this was enclosed by a brick wall with iron-work ornamentation. Just outside the main gate was a row of what looked like toy cottages, each with a bench round it and its own yard, two or three windows and a roof and chimney. These were cells where nuns had lived in the old days. When we were children we used to peep in at the windows and saw that they were just like cottages inside too: tables with samovars and sugar-bowls on them, neat rugs and whitewashed Russian stoves.

The cells were now very decrepit: they had sunk into the ground as far as the windows, and the eaves of one were already touching the green grass. In one of these dwellings we

84

were to find 'old Nikolay', the blind and feeble custodian of the empty church. Bending down, we made our way from the porch into a kind of hall, struck several matches and found a door that was latched on the inside. We knocked politely in the usual way, but the door was a stout one and was covered with a ragged blanket; our knuckles made no impression, so we started banging with our fists. As there was still no sound or sign of movement, we tugged at the door and shouted Nikolay's name. Dead silence.

A cat, attracted by the noise we were making, came up and started running to and fro in front of the door. Evidently she had been shut out for some time and now hoped to slip in when the door was opened for us ... We began to feel alarmed. Could the old man have died? He was blind, deaf and feeble, with no one to look after him as far as we knew. One of these days – perhaps today – people would come along and knock and tug at the door, and then if nothing happened they would have to take an axe to it or climb in by the window ... The cat was running around impatiently, pressing its nose to a crack in the door and scratching at the panel. Curious as it might seem, the scratching was more effective than our knocking. At long last something stirred on the other side: we heard a scraping noise along the door-frame, the clink of a latch, and the door opened wide.

Old Nikolay, with his parchment face and yellow beard, moved aside to let us in. The cat rushed forward to get at its food-dish, looked appealingly at its master and began to rub against his much-repaired felt boots.

The old man was almost stone-deaf, and could not make out who we were and what we wanted. By bawling into his ear we were able to convey the bare gist of what we were there for, but there could be no question of a cosy conversation that would have led him to take a kindly view of this surprise visit.

He was too blind to make out our features, so our only contact was by shouting in a way that filled the cottage with din and could probably be heard all over Cherkutino.

'We've come to look at the church – the church!'

'Are you going to pull it down? Why couldn't you let it stand a bit longer?'

He spoke in a kind, soothing voice as one does to children, which made my shouting sound even more absurd.

'No, we don't want to pull it down, we just want to look at it. Is there anything left inside? Icons?'

'You want to burn the icons? Why don't you let them alone for a bit?'

'No, not to burn them! We're interested in antiques – paintings. Can we have a look inside the church?'

'I haven't been in for a long time. But I can tell you that the women cleared it out ever so long ago. One after another they came and said "Nikolay, let's have an icon!" And I thought to myself, well, they'll only be destroyed anyway, so the women might as well take them. "Take them and pray to them," I'd say. "They'll only be burnt if they're left here." So after a while they didn't bother to ask me before taking them, and then I got blind and feeble. Sure as anything they'll have taken the whole lot by now. But go and have a look if you want to. The church isn't locked, anyone can go in and take whatever they like. But it's years and years since I was inside it.'

We went through the graveyard gate and found ourselves on a broad, straight path overgrown with weeds. On both sides of it, vegetation that had grown unchecked stood like a green, untidy hedge. At the far end of this path or avenue we could see the little wooden church. The graveyard was not disused – people were still being buried there – but it was appallingly neglected. The eighteenth-century lime-trees had spread in all directions and intertwined their branches, turning

the space beneath into a greyish twilight. For decades, twigs from innumerable rooks' nests had been falling to the ground and decaying; the very composition of the earth had changed as the years passed. The ground was strewn with bones and rotting pieces of wooden crosses. We hastily turned back from this jungle to the path, where there was sunlight and fresh air and we could see the little church ahead.

Walking round the building, we found that the main doors were locked, which confirmed the impression that the place had been closed but not simply left to fall down. A side door was blocked from within by some obstacle, not very heavy, which proved to be a cupboard: we pushed, and it gave way. Even the main door, though locked, did not prevent people getting inside: all four panels had been knocked out and there was nothing left but the crosspiece, from which hung a massive padlock resembling a small barrel.

Being free to use either entrance, we chose the main door. Just within it, our eye was caught by a narrow flight of steps leading to the church attic.

In old Russia there were many ways of destroying dilapidated icons. One was to take them to a crossroads and burn them, to the accompaniment of prayers. This was not often done, but the custom was described to me three times in different parts of the country. In general it was a great sin to burn an icon, but an even greater one simply to throw it away. The most usual way of getting rid of those that were no longer fit for use was simple, but original: they were disposed of 'by water'.

'Tell me, Granny, have you got any very old icons?'

'We've got the ones we pray to ourselves – none to spare.'

'I don't mean the ones you pray to – I mean those that are so black you can't see anything. Are there any like that in the loft?'

'There used to be some, but you're too late – I sent them off by water.'

'By water – what does that mean?'

'It's what they used to do in the old days. It was a sin to burn them or throw them away, and an icon doesn't like to be in a dusty old loft – it likes to be rubbed with oil and have a light burning in front of it. Up there it's all dust and mice and spiders and such-like nasty things. So what we did was, we wrapped the icon in a cloth and took it to the river in flood-time, and we made the sign of the cross over the poor thing and let it float away, with the holy image facing upwards. It was nicer for it like that, with the sun shining and the bees flying all around, and the birch-trees standing up straight and still.'

If all disused icons had either been burnt at crossroads or allowed to float away into eternity, no one at the present day would have the joy of seeing any old Russian painting. Fortunately for us there was a third possibility: the old painting was covered by a new one, and in this way it was preserved for posterity. As for the old, blackened ones that were disposed of by fire or water, they were bound to be stored at first in the loft of a church or peasant house. So, when we saw the narrow stairway in the church at Cherkutino, we made haste to climb it. Every other step was missing, and the rest were rickety – it was all slowly decaying and crumbling away. The first thing we found in the loft was what looked like a great heap of pigeons' droppings. We imagined that there must be something or other concealed underneath, and we were right. Under a layer of droppings three or four inches thick was a heap of small wooden icons like those found in people's houses. There were a hundred or even more, and it was clear enough where they had come from.

The church was attached to a graveyard, and the custom

was that after the funeral service the relatives would leave an icon in the church. It was supposed to stay there for forty days in a specified place, after which they would take it home. But very often they left it in the church, which thus gradually became full of these 'funeral' icons. In time there was no more room for them, and so the older ones were stacked away in the loft.

One day I heard that in a village church twenty miles away from us there was a cupboard full of copper icons, the kind of work described in museums as 'antique castings'. The whole lot were said to weigh about a hundred pounds. It rained for several days after I heard this story, so that I could not go and look at them straight away. This did not worry me: the church had been closed in the thirties and had been a collective farm storehouse for twenty-five years, and if the copper had survived that long it would last a little longer. But the delay proved fatal. When I arrived I was told that some schoolchildren had come along and taken all the copper for scrap-metal.

They would not have got any satisfaction from the objects we dug out from under the pigeons' droppings – a hundred and sixty rotting boards, each of which not long ago had been an icon and only needed the restorer's hand to make it shine in beauty. The cause of the icons' ruin was that the church roof had sprung a leak right above them: the rain had dissolved the paint and rotted away the boards. We could only tell by looking at the backs which of them belonged to the sixteenth century, which to the seventeenth (a good many), and which to the eighteenth (the largest number) or to quite modern times.

It was easy to see why most of them belonged to the seventeenth and eighteenth centuries. The first funerals in this church had taken place in the eighteenth, and on such occasions people would bring out their oldest icons, those they no longer wanted at home. Three of them we tentatively dated to the six-

tcenth century. But all this meant nothing now – the damp and pigeons' droppings had treated all the centuries alike. Of course the icons had varied in artistic merit too: some would have been derivative, journeyman's work, others full of beauty and inspiration. But to my mind, even the work of an uninspired journeyman is of interest if it is four hundred years old.

Having lamented the fate of the ruined icons, we decided to go down and look at the rest of the church. There was not much time left: it was getting dark, especially here in the graveyard, with the lime-trees overhanging the church on all sides.

As soon as we opened the door into the main body of the church, we were deafened by a panic beating of wings. The pigeons, startled by our arrival, were flapping wildly about under the dome. We in our turn were taken aback by this sudden burst of noise in the darkness of the old church. Gradually it diminished: the pigeons found a window to escape through, and we began to look about us.

What we saw was indescribable. Usually, when churches are closed, all the furniture and other contents are removed and the place turned into a club or a warehouse, or demolished, But in this case, after closing the church they had simply forgotten its existence. All the furnishings such as copper candlesticks, cupboards, lamps, books, chains, bits of linen and so on had been left there to disintegrate during the next twenty-five years. The candlesticks had been thrown down, the lamp-chains were broken, the cupboards were overturned and the books scattered page by page. The windows were broken; so was the glass in the icon-frames and the coloured lamps, and at every step we took it crunched under our feet. Bronze overlays had been wrenched from the icons and were lying about, twisted into every conceivable shape. The oak altar-table in the sanctuary had been turned upside-down and the

underside hacked about with a crowbar. In the iconostasis there were gaping sockets where the icons had been, and its carved and gilded cross-beams, piled high with pigeon-droppings, completed the picture of devastation.

One might have spent a long time wandering about the church and examining the objects that lay underfoot. Later on we did so, finding for instance a book printed in the seventeenth century, a small embossed plate made of silver-plated copper, an oval medallion from a wedding-crown and a glass lamp-chimney as red as a genuine ruby. All these things we saw later, at our leisure, since we were able to visit the church as often as we liked. We went back four times in all, and on each occasion we found some beautiful and ancient relic.

At present, however, we were in a hurry and had no time to look about for small plates and lamp-chains. Our only concern was to search for the icons that might have found their way from the parish church at Goryamino to that at Cherkutino and thence to this church in the graveyard. But the result was a complete disappointment: the iconostasis was bare, the villagers had carried off every single icon either to pray to it or use it for firewood, with the exception of the small ones in the top row forming the 'Deesis group'. They had left these alone because they were almost impossible to get at. A man might have climbed up by way of the carved gilded cross-beams, but once there he would still have had to loosen planks and prise the icons out of their sockets, working with one hand, in an awkward position and at the risk of losing his hold and crashing to the floor. The desire to get something from the church, even for firewood, was not a strong enough incentive: what was needed was the enthusiasm and fanaticism of a collector, or a hunter's delight in overcoming every conceivable obstacle.

I don't remember how I managed to clamber up underneath

the dome. Dried-up pigeon-droppings fell about me, stuck in my hair and got into my eyes. Bits of gilt carving snapped off when I took hold of them but the laths that protected the icon-sockets held fast. After immense efforts, hanging on by my left hand which was rapidly growing numb, I managed to prise one icon free. To climb down while still holding it was beyond my strength or skill: I threw it to the ground at the risk of breaking it, knowing that any collector would call me a criminal for doing so. Luckily it was protected by a massive copper frame which also covered the front and sides. Down it went: I heard shouts from my friends, a crash which echoed round the dark, lifeless building, then silence. When I reached firm ground again, my arms and legs were trembling from the strain.

We took the icon outside to look at it in the light. How pleasant it was to breathe, standing on the grass in the open air! We tore off the coarse, clumsy metal frame and found the icon to be long and narrow in shape and rounded at the top. Then came the critical moment: removing the nails that held the metal overlay in place, we lifted it off the picture. It was like the unveiling of a monument, or a curtain going up in the theatre, when the spectators gaze in admiration at the sculptor's or decorator's art. We too exclaimed in admiration, for what met our eyes was an unusual sight.

As I mentioned before, all old icons are slightly recessed, so that a rim is formed by the outer edge of the panel. This is the first sign of antiquity, of a thoroughbred icon so to speak. As soon as the overlay was off we eagerly felt the surface of the picture: sure enough, there was a rim of a millimetre or two, which could be both felt and seen. But what was this? The rim was rectangular in shape, yet the upper edge of the icon was curved. It had in fact been knocked into a rounded shape with careless blows, cutting across the rim itself, and it was this

that filled us with triumph. Clearly the icon had once been rectangular and fixed in a socket of the same shape, but had then been moved to another church where the frames in the iconostasis were rounded at the top, so they had taken an axe and trimmed it to make it fit . . . This much we realised as we sat looking at it in the cool evening, on the grassy patch in front of the graveyard church. When we got home and had laid it on the 'operating table', we were able to collect our thoughts and work out the story further.

The graveyard church was built in 1798, and it was then that the icon had been reshaped and restored: the painting we saw now must date from that year. Before 1798 the icon had been in Cherkutino parish church, and it must have been there for quite a long time, since it was one of the shabbier ones that were relegated to the little wooden graveyard church. In any case it would not have been large enough for the new brick church: the master who painted it would have designed it for a wooden building.

The next point was this. When the Goryamino parish church was moved to Cherkutino, some of the old icons were retained and other new ones were painted. There was no doubt of this: every new church had to have some new icons. Moreover they would certainly have repainted the Goryamino icons to make them uniform in style with the new ones. The question was whether the icon we now possessed was one of the repainted ones from Goryamino or a new one from Cherkutino. Only the chemical solution could give us the answer. If there proved to be three layers of painting it would mean that this was a Goryamino icon. So we made haste with the flannel and tweezers, the glass slab with a weight on it; we waited five minutes; we applied the cotton wool and scalpel with bated breath, feeling an indescribable sense of discovery, of penetration into the secrets of time, of contact with antiquity.

The first painting, the greenish-brown one of 1798, came off easily, which caused us no surprise. We had been quite sure it would, since it obviously did not match the panel or the rough-and-ready shaping of its upper part.

We made a test by placing the square of flannel in such a way that half of it lay on the silver halo of the Archangel Gabriel and the other half on the brown background of the topmost picture. When this picture was removed, the square consisted of a blue background and a bright green halo. The next step was to penetrate from the early eighteenth century to the mid-seventeenth. The blue and green soon yielded to the chemical solution and came off on to the cotton wool or the blade of the scalpel. Under the blue background we found a green one, and under the green halo was the purest ochre.

Gently, gently! We had now reached the Goryamino of olden days, before the church was taken away from it. Gently! Each layer of painting represented a century. We had moved back from the mid-eighteenth to the seventeenth, and now, if all went well, we should remove the last overpainting and discover the authentic original, the holy of holies.

Each century had had its own design: a brown background and a silver halo, then blue and green, then green and ochre. What colours had the original artist chosen, and was his painting better or worse than his successors'?

With the utmost care we set about removing the green background. We felt apprehension too: after all, this was the middle of the seventeenth century, and what if we found nothing underneath? Of course the piece of flannel was a small one – this was merely a test. If there was nothing underneath, we would rest content with the seventeenth century and take off only two layers . . . Gingerly we removed a patch of the seventeenth – the tender green disappeared, revealing the pure, sonorous, solid ochre of the sixteenth! What is more noble

than the colour of antique ochre, especially as the background and border to old icons!

We now had ruthlessly to remove the seventeenth-century ochre of the halo. What should we find underneath? What colour had the sixteenth-century artist chosen for the halo, to combine effectively with the splendid, spacious background and to dominate it, as a singer's voice dominates and blends with a musical accompaniment?

We had not long to wait. As the ochre dissolved in the solution we saw the vivid, almost unbearable brilliance of pure, radiant gold.

'It's gold, it's gold!'

'There it is, that's the sixteenth century!'

Next day our neighbour, who had heard our wild cries as she walked past the window, said to me: 'What was that gold you were shouting about, have you found some treasure?'

'You bet we have, Marusya – the biggest treasure you can imagine!'

Two years later, in a church where services were still being held, I saw a set of similar small icons depicting Festivals: Christmas, the Transfiguration, the Presentation of the Virgin, Christ's Descent into Hell. The icons did not belong to that particular church, but were standing in a row on a window-sill, like books on a shelf. I asked the priest if I could have them, and to my surprise he agreed.

'Yes, take them if you like. I've been meaning to hang them up for ages, but it means taking a chisel to the brick wall so as to put screws in.'

'Where did you get them from?'

'From the church in Cherkutino cemetery – a little wooden church, you may have seen it. They were the last ones left, except for some in the top row, but you couldn't get at those without a ladder.'

The icons the priest gave me had also had their top corners rounded with an axe, and they also turned out to have three layers of overpainting.

It seems quite a short while since we were clambering about the shaky iconostasis and poking around among bits of glass for odds and ends of church ornaments and pages from books. But that too is now a thing of the past: the graveyard church has been pulled down.

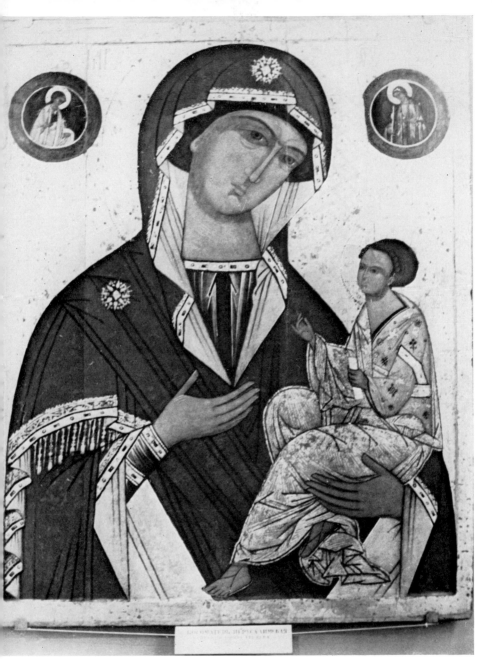

'The Virgin of Jerusalem', 16th century, from Vologda

9

ONCE I went to the Executive Committee office of the local soviet to ask if there had been any routine closing of churches in the district. What usually happens on such occasions is that the church is locked up and left alone for a time, no doubt so that the inhabitants can get used to the situation. The church is not used but is preserved intact, as though nothing particular had happened, and the faithful are free to hope that it may not be destroyed, that it may even perhaps be reopened some day . . . I know in fact of two churches that were left untouched in this way for years: such cases are not typical, but I will describe one of them.

There is a street in Moscow called Stromynka, and there used to be a highway with a similar name which, it appears, was named after a village called Stromyn. When I learnt about this village I went at once to have a look at it. In the middle of the village was a brick church surrounded by a tall fence. It was obviously disused, but for some reason it had not been pulled down. I asked a passing woman who kept the key and where, and received the surprising answer: 'There's no key.'

'But there must be. If it's not with one of the parishioners, for instance the former sexton, then surely the village soviet must have it?'

'The village soviet's key is neither here nor there. There are two locks on the church – one the soviet's, and one ours. Why do you think the church is still unharmed? – because the soviet can't get in unless we let them. They shut it all right, but we've got our own key.'

I went to investigate, and found that it was hard enough to get near the church, on account of the high wooden fence. I could see from where I stood, however, that there were two padlocks on the church door: a modern one that any small boy could open with a bent nail, and a large, elaborate, old-fashioned one. It seemed to me that the two sides were unevenly matched. The parishioners would not have much trouble in getting into the church if they wanted to, but it would be hard for the local soviet to do so without their help.

I resolved to get to the bottom of the matter, and continued to ask every woman I met who the ex-sexton's wife was and where she might be found. But it was clear they were all in a conspiracy together. Either they said there had never been a sexton, or that the church had been looked after by a girl who had married someone in another village, or that the caretaker had died and no-one knew where she had hidden the key. Finally a young girl, probably a vet or a medical student and not a native of the village, gave the show away unsuspectingly by telling me where to find the home of the woman who looked after the church.

What followed was like something out of a comedy. It turned out that on that very day the pious women of Stromyn had gone off to petition the Executive Committee, doubtless not for the first time, to re-open the church. They had got back to the village about a quarter of an hour before. The authorities had told them that somebody would come and have another look at the church, and now I was being taken for that somebody . . . Ten or fifteen women gathered in no time – some of them were members of the deputation, but they were now joined by others who had stayed at home.

'Goodness me, he got here quickly.'

'How can he have got here before us? We didn't stop any-where.'

'I expect while we were talking to that man in glasses, he just slipped out and got in his car and came straight along.'

'Wanted to get in first, I dare say. But he won't get the better of us that way.'

I found it amusing to maintain the role of visiting official for a while, not telling a lie but simply letting the old women remain under their misapprehension.

'All right then,' I said, 'where's the key?'

'The parish people have got it.'

'Yes, but who exactly?'

'They all keep it.'

'How many are there of you altogether?'

'There's eleven villages in the parish – we've never counted how many people.'

'So the key's kept in eleven villages at once? Come on, there must be somebody who has it.'

'There's no key. What do you want it for, anyway?'

'To look inside the church.'

'There's nothing to look at. You can see the outside – the inside's empty.'

'Look, I came here to do you people a favour. You make a fuss about opening the church, and as soon as somebody wants to look at it, you hide the key.'

They began to whisper among themselves.

'Shall we give it to him, for our own sake?' I heard one of them say.

'Don't be silly. He'll take it and clear off in his car, and next day the trucks will come and they'll blow it up. It's happened often enough hereabouts.'

'I reckon we should give it to him. He doesn't look bad, he's got an honest sort of face.'

'They all have.'

I decided to add fuel to the argument.

'Well, it's up to you. I'm going now, and you can have five minutes to think it over. After that you won't get another chance.'

This flustered them. I heard one say: 'What's there to be afraid of, anyway? Here, Marya, give me the key. I'll unlock it for him but I won't hand the key over. He's not likely to take it by force, and I'll die sooner than let him have it.'

'What if they've all come in their trucks and are hiding somewhere near by? Then once we open up they'll rush into the church, and we shan't get them out again, and during the night they can blow it up, or take everything from inside and just leave the walls standing.'

'Well,' I asked, 'what's the answer? Will you give me the key?'

'No, we won't. We'll only open the church if you let us have a priest to hold services.'

'Where am I supposed to find a priest? I only came to look at it.'

'We know your tricks. There's no key here. Bring us a priest, and you can have it and welcome.'

*

Stromyn, as I said, is an exceptional case: it is very rare for a church to be closed but not destroyed. Generally when the authorities close a church they let the diocesan clergy come and look over it: the priests may take away a Gospel-book or a newish vestment, but usually they take nothing at all, and the visit is just a formality. Next come two or three members of the local department of culture, to see if they can lay hands on any precious metals. It's a long time since there was any gold left in Russian churches, but if there are any silver overlays on the icons they rip them off and cart them away in sacks. Church books don't interest them, and neither does a painting as such.

Far be it from me to criticise the cultural officials: all this church business is not really in their line at all, their job is to set up clubs and rural libraries, organise amateur dramatics and all that sort of thing. Then suddenly they are told to go and have a look at some church property and decide which of it is worth keeping and which isn't – stuff they've never seen or thought of in the whole of their lives. How can they be expected to sort it out and decide what to do with it? Besides, they may well think: 'The priests have been here already. They know about this sort of thing, so surely if they haven't thought fit to take anything out of the church, it's because there's nothing worth taking.'

In any case, after the church and the local authorities have made their inspection, the powers that be feel assured that there is nothing of value left. So the church is made over to the nearest collective farm to serve as a garage, a storehouse or a carpenter's shop; usually a storehouse, as that involves no rebuilding. All they have to do is to empty the interior, leaving nothing but bare walls – bare, that is to say, except for the paintings on them.

Some objects, however, may survive the clearing out of the interior. Suppose a window is broken and there are no planks at hand to board it up with – what is simpler than to use one of the icons that would otherwise be thrown out? . . . Consequently, however long ago a church may have been closed, a collector should never ignore it. He should walk round it, look at the windows and glance inside, if only to admire the architecture. He will do better, though, to visit it not thirty years after its closure but during the short period between the inspection by the district authorities and church representatives and its effective take-over by the collective farm.

That is why I went to the Executive Committee to ask if any

nearby churches had been closed recently. Yes, they said, there was one at Petrokovo.

'Has it been handed over to the collective farm yet?'

'Yes, it has.'

So I rushed off to Petrokovo. It was past noon on a sunny July day, with bluebells everywhere. When the sun is high in the sky everything has a flat, blurred, hazy look; but as the afternoon advances, the thicket on the hillside, the birch-tree on the edge of a cliff, the shrubs and the tiny village and every-thing around present a sharp, clear, three-dimensional appear-ance. So do the cumulus clouds, while the blue vault itself takes on a richer and more limpid hue, till it finally appears a perfect azure. This is the time of day at which white churches and bell-towers, seen across a field of rye or behind trees, are especially beautiful and appealing.

As we drove along, I asked my companion to read out what our book said about Petrokovo.

The village of Petrokovo is situated among wells and springs, twenty-five versts from Vladimir. It was formerly an estate of the monastery of the Saviour and St Euphemius at Suzdal, to which it was given by Prince Dmitry Mikhailovich Pozharsky in 1633. The charter reads in part: 'I, Prince and Boyar Dmitry Mikhailovich Pozharsky, together with my sons Peter and Ivan Dmitrievich, do hereby make this grant unto the religious house of the Most Merciful Saviour and the Wonder-Worker Euphemius, ruled by the Archi-mandrite Porfiry . . . in memory of my son Prince Fyodor Dmitri-evich. And we, the Princes Peter and Ivan, in memory of our brother do likewise grant as an estate this village of Petrokovo in the Vladimir province, with its church of Saints Florus and Laurus and with the peasants and cottagers and all forests, pasture and waste land . . . And in return for this he shall be remembered at the altar and requiems sung for his soul . . .'

In 1736 a fire broke out in the church of Saints Florus and Laurus, of which the priest Aleksandr Ivanov made the following report to the office of the Most Holy Synod: 'On the tenth day of July in this year of our Lord 1736, in the church of the holy martyrs Florus and

Laurus in the village of Petrokovo on the estate belonging to the monastery of the Saviour and Saint Euphemius, certain vestments caught fire by reason of a candle falling from the altar, and the fire having spread to the building, it is not now possible to hold divine service therein . . . '

The present church was built in 1829; it is of stone, as are the bell-tower and precincts.

As I heard these words read out, a bell-tower came into view through the forest. From the distance we had travelled and the appearance of the place it was clear that this was Petrokovo, the object of our anxious and impatient quest.

Even from a distance it is easy to tell a live, functioning church from one that is disused and dead. But this was a special case, because the church had only recently been closed and had not yet taken on a blighted and desolate air. It stood there, to all appearances cheerful and alive, at the top of a hill golden with wheat. But we knew that it was really dead and that there was little chance of its coming to life again.

We found the manager of the collective farm, explained who we were and asked if we might look round the church.

'You people are going to clear out the inside, and there may be things that would interest us, like books or icons. Of course, if you don't want us to, that's that – we're only asking.'

'You should have come two days ago,' the manager replied in a tone of genuine regret.

'Why, what difference would it have made?'

'Quite a bit. This place was given me for a storehouse, so I had to empty it, right? Well, I decided to do it in one swoop and get it over with. I got a team of carpenters to work with axes, and you know those boys – there's no stopping them. In half a day they smashed every blessed thing to pieces.'

'When was this?'

'Yesterday. I told you, that's why you ought to have come

two days ago. Everything was still there then, as bright as a new pin.'

'What about the pieces – were they carted away?'

'No,' the manager replied with satisfaction. 'The pieces are still there – nothing whatever's been taken out of the church, it's all still inside.'

We said nothing.

'It never entered my head that anybody would want the stuff.'

*

I have noticed that as far as icons are concerned, people may be divided into four unequal categories.

The first are the pious folk for whom an icon is a holy thing, not to be treated with contempt or even with admiration as a mere work of art, but a religious object which must not be sold or allowed to leave the place to which it belongs.

The second category are the iconoclasts, who believe that religion must be stamped out, the sooner the better, and all icons destroyed.

The third – the most numerous – group are the people who have never thought about icons from either the religious, the artistic or the historical point of view. They vaguely know from their childhood that an icon is something outlawed, a relic of the past, a useless, unimportant object which does not belong in any way to the real world.

I have noticed that people of this class can become very much interested in icons if they suddenly realise that they are things of artistic and historical importance. Their attitude towards you and your quest immediately alters: they will help you to the best of their ability, exclaiming in a repentant tone: 'My goodness, what a fool I was! To think we had all those icons lying about in the attic. But I didn't know, I didn't realise.'

People like this can change their attitude completely in the space of an hour or even fifteen minutes, and from then on you can be quite sure that they will never let an icon be used for firewood without first showing it to a specialist.

The fourth category, of course, are the collectors. To them an icon is of value as a historical, artistic or national treasure, and also as the object of their own collecting fervour. Of course the collectors too may be subdivided. Some collect icons in order to save them for the nation; others see in them a source of private profit; others again are carried away by the sort of undiscriminating passion which may be excited almost as readily by icons as by the labels of brandy-bottles . . .

*

'It never entered my head that anybody would want the stuff.'

The church walls were bare, though the oil paintings on their surface still remained. Everything else, including the iconostasis – the whole wooden framework which supported the icons, the birds and flowers carved in wood and gilded, the icons themselves – everything had been dashed to the floor and chopped into small pieces. The pile of golden-blue and golden-red fragments rose nearly half as high as the church vault itself. Yes, the carpenters had made a good job of it.

'Of course, there was nothing specially old here,' said the manager, whether to console us or himself was not very clear. 'The really old stuff was at Annino.'

'Is it still there?'

'Hardly! They pulled down that church in the thirties, and some of the things from it were brought to this one. They were old all right, even I could see that.'

'And what happened to them?'

'All smashed up here with the rest.' He nodded at the glittering pile. 'There was a statue that came from Annino,

taller than me, about six foot six it must have been, made from a single block of wood. It was a chap with a beard and sandals, leaning his cheek against his hand in a sorrowful sort of way. Quite an interesting one, that was.'

Rummaging in the pile of fragments we would notice part of a hand, a segment of beard, an eye . . . From under the pile I pulled out a small square Festival icon, an Entry into Jerusalem. The panel was a thin one and had been split by an axe-blow on the reverse side, but the stout canvas on the front had prevented its breaking apart. I pressed the two halves together as hard as I could, so that the picture was more or less intact except for the scar down the middle where the paint had come off. I dug about and was able to rescue seven more Festivals: they were all mutilated, but I was able to mend them in the same fashion, much as a human thigh-bone might mend after a fracture.

'Your carpenters weren't quite so thorough after all,' I said to the farm manager. 'What about the other four? – there ought to be twelve like this.'

'Four were taken away – the women grabbed them and took them home. And the reason these are not chopped to bits is that it wasn't the carpenters who broke them up, but the man from the education department. The women came in while he was looking over the church, and they made a dash for these pictures – they're quite pretty, small as they are. Look at the fellow riding on a donkey . . . Well, the women started to grab at them, and so they shouldn't have them he took an axe and bashed them about – but of course an office chap like that doesn't know one end of an axe from the other. So they're just a bit dented, but if it had been our carpenters – well, you can see for yourself, it'd have been a different story. Yes, they know their job, those fellows, and no mistake.'

The Festival icons turned out not to be very old, but I have kept them none the less.

10

As we took leave of the manager on the steps of the Petrokovo church, we asked him whether there was any quicker way back than the one we had come by. He replied: 'While you're around here, why don't you go and look at the Volosovo monastery? It's quite near by.'

When I was a child I had often heard from my father, who liked travelling about the countryside in a cart drawn by one of his favourite horses, that there was a place called the Volosovo monastery, but in those days I imagined it to be at the end of the world.

Up till now I had always thought that Russian churches and monastery buildings looked at their best when situated on a hill, a high river-bank or raised ground of any kind. When you stand at the foot of a bell-tower and look up at it piercing the heavens, the white clouds sailing past it give the impression that the tower is falling. If, on the other hand, you look at the main church building with its mighty array of domes, you get a different sensation, as though the whole gleaming white and gold structure is itself floating through the clouds, which move just sufficiently to allow the marvel to pass between them, like a galleon through waves.

In those days I had not seen the Pskovo-Pechorsky monastery which lies in a deep ravine, nor had I looked down from the high bank of the Dniestr on to a certain monastery in Moldavia: so I was the more impressed by the sight of Volosovo.

We had driven to the top of a high hill, and saw below us a wide, deep valley, or rather two valleys intersecting each other.

The point where they crossed was the lowest in the landscape, and there we saw the white monastery, looking like a toy. A sparkling river ran past it, and the woods on the slopes above looked like a bluish cloud. The buildings could scarcely be picked out in their setting of peaceful greenery.

How absurd and incongruous, we thought, to find such an idyll amidst the harsh reality of the present day. But we had judged too soon. When we approached closer we found signs that a fierce fight had indeed been going on here; both sides had withdrawn from the field, but it was still in disorder. There were, of course, no dead bodies; but the place was full of rubble, parts of the building were destroyed, battered or patched up, and the dome of the church had had its crosses knocked off. A tractor stood near by, looking like a tank that had been put out of action; motor-tyres and scattered piles of firewood lay about in confusion. In short, there was every sign that a clash had taken place between two hostile forces.

We walked round the monastery building, looking for a door by which we could enter, but everything was locked and boarded up. Then we came on some narrow steps, leading down to a door which, though battered, did not look completely disused. We knocked, and a quavering voice answered us from within. We pulled the door towards us and found it unlocked – indeed it was apparently unlockable, as there was neither a key-plate nor a staple for a padlock. Groping along the dark basement passage, we came to a second door, which opened into a room four yards square. When our eyes got used to the gloom we found that it was something between an oratory and a monk's cell, with a lectern in the middle and a religious book lying open on it. The walls were hung with icons, some in metal frames, and there were icons on the high window-sill: the room was very lofty in proportion to its area, and as the walls were five feet thick there was plenty of

room for icons in the window-embrasure. The lectern was bespattered with yellow wax-drippings from cheap candles, one of which was guttering beside the open book. A few lamps glimmered in front of the icons. The room also contained a stool and a narrow iron cot.

In front of the taper and the open book we saw a tiny, bent old woman dressed in black. Her whole body trembled feverishly: her hands, her shoulders, her head, her lower lip and her tongue as she strove to get words out. None the less, we managed to hold a conversation with this strange being in her out-of-the-way habitation.

'I live alone here, all alone. Yes, I'm a nun. They pulled everything down, and I'm the only person left. I made this little cell for myself, and I get along somehow. So far they've left me alone. What's my name? Mother Eulampia. Before I was a nun? Oh, my dears, that was a long time ago, what's the good of remembering? Katerina, my name used to be. Anyway, here I am looking after the icons. I'm still alive and I look after them. I keep the flame burning night and day.'

'Who put you in charge of the icons? Who asked you to look after them?'

'Why, God, of course. I protect them by God's order.'

'So I suppose this is your main business in life, your chief duty?'

'It's the only duty I have. As long as I'm alive, my one business is to keep the flame alight in front of the icons. When I'm gone, the candles will go out too.'

'Where are these icons from?'

'Some from the convent church, some from Annino. There used to be a beautiful old church there. When they pulled it down a lot of the icons were taken to Petrokovo, but I got them to give me the Virgin of Kazan and the Archangel Michael, and St Nicholas there as well. It's a wonder-working

icon of St Nicholas, people for miles around used to worship it, and now it's here. The church at Petrokovo is still open, it's not been destroyed and they hold services there. I ought to go there to pray and be cleansed of my sins, but as you can see I'm in no state to go anywhere – I'll not see Petrokovo again.'

'Mother Eulampia, there's no reason for you to go to Petrokovo now. The church has been closed, and all the icons smashed to bits with axes. We've just been there and seen it. So you can set your mind at rest about going.'

She made a movement as if clapping her palms together, but her hands were so paralytic that no sound came. Her aged face quivering, she turned to the icons and began to cross herself, whispering: 'Lord, forgive them their folly, they know not what they do.'

Afterwards she allowed us to look at the icons, and I examined each one in turn. It was difficult to take down those that were hanging on the walls, and I had to be content with looking at their faces; but the ones standing in the window I was able to pick up and look at thoroughly. One of these interested me especially. It was a full-length representation of the Archangel Michael, measuring something over a yard high and a foot broad. The panel was coal-black and badly warped, worm-eaten in places and showing the marks of rough treatment with a scraper. The cleats were narrow and extended across its whole breadth, close to the ends. But I need not enumerate the details – it was obviously a sixteenth-century panel. The painting, on the other hand, was a commonplace piece of late nineteenth-century realism, in light blue oils . . . I should have asked Mother Eulampia for the icon then and there. It was, after all, not one of her principal ones, as it came from the pile in front of the window. But I was so affected by the tiny room and the old woman, by finding her in the deserted monastic building and by her strange self-imposed duty of keeping alight a flame

whose feebleness matched that of her own life – all this so moved me that I could not bring myself to ask her to give me the Archangel Michael.

*

Two years later, Sergey Larin, a writer from the Vladimir province, invited me to go with him to visit the woman who had been his first schoolteacher. He was writing a book about his childhood and wanted to talk to her and exchange memories. So off we went.

It was an enjoyable trip. We stopped first in the village in which Sergey was born, to visit his family and celebrate his return in proper style. We sat on a river-bank where he had fished for gudgeon as a small boy, and naturally celebrated further before leaving such a famous spot. We then learnt that his old teacher had moved to another village not far off, and we set out with all speed to find her. When we did, it turned out that her home was quite close to the Volosovo convent. I had never been able to forget my visit to that place, the Archangel Michael and the sixteenth-century panel with its worm-holes and the marks left by the scraper. I had regretted many a time that I had not had the courage to ask Mother Eulampia for the icon. But I felt sure that she would never have parted with it, knowing as I did how hopeless it generally was to try to get an icon out of the hands of a pious old woman.

Our trip had been a merry one, and we did not reach Volosovo till late afternoon. Sergey's teacher had gone to see a film in the village recreation hall. Someone went to look for her, and we sat down to drink tea with jam and look at an album of school photographs. By this time it was quite dark.

I could not shake off a desire to go and see the old woman at the convent once again. I had no idea whether she was still

alive and tending the flame, but I could not bear the thought of being a few steps away and not going to see the Archangel Michael. When I told Sergey the story, he agreed to my plan with enthusiasm, and we set out to visit Mother Eulampia.

We went down the same flight of steps in the darkness, and again I pulled open the outer door; we walked through the inner one, and there were the candles as before, Mother Eulampia stood bent over the lectern in exactly the same attitude as she had two years before – as if she had neither slept, nor sat on the stool, nor moved in any way throughout that time, but kept watch like the faithful sentinel she was.

When she heard us approaching, she ceased her prayers and put a match to a large stearin candle. When the room became lighter I saw that her face, too, was absolutely unchanged.

We younger people are inclined to think that when a person's life is going downhill, each day must bring about its share of erosion and destruction. But if you look at people in this condition, you find that they rub along with little change: the years come and go, while the man or woman looks no better and no worse for them. It would seem that an organism that is due to collapse arrives at a kind of dead level, a melancholy but stable equilibrium. At any rate, here was Mother Eulampia, still the same two years after. I thought I would try to revive her memory.

'Mother Eulampia, do you remember my friends and me coming here two years ago, in summer?'

'I expect I might, but I'm old – very, very old.'

Sergey, to whom the old woman and the icon in the window recess meant nothing in particular, was more at his ease than I was. Being an editor and full of news sense, he started to ask questions about her practical arrangements and way of life. While I thought of her simply and solely as the custodian of the sacred flame, he was determined to find out what she lived on,

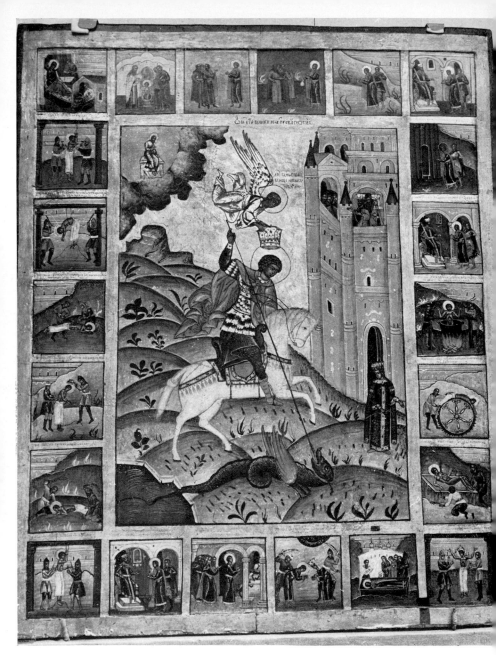

Icon of St George and the dragon, surrounded by a set of miniatures showing the life of the saint, from the Preobrazhensky Church in Kizhi

what her monthly budget was, where she got food and who looked after her.

'People come here – women from the village. They bring me a little bread, or some sugar, or a kopeck or two. And I don't eat much, no more than a sparrow.'

Talking like this of everyday things, my friend and the old woman were soon on good terms. Seeing that his manner made an impression on her, and feeling certain that such an opportunity would never occur again, I suddenly said: 'Mother Eulampia, do you think you might give me that icon there in the window-embrasure? It doesn't seem to be a special one.'

I fully expected the usual reply: 'Good gracious, do you think icons are there to be given away or taken out of the house? How can I give you something I've been ordered to protect for the rest of my days?' And, knowing from my previous visit whence the order came, I had spoken as much to relieve my own feelings as with any hope of success. But Mother Eulampia only replied quietly:

'You won't throw it away, will you?'

'Mother Eulampia, as if we could! Do you think . . .'

Her trembling face turned towards Sergey, she said: 'What do you advise me to do, sir? Shall I give him the Archangel Michael?'

'Yes, Granny, don't you hesitate, give it to him. The icon will be in good hands, he knows about these things.'

'Very well, then, as it's God's will, you may take it.'

We left Volosovo with our headlights blazing. As the road turned and twisted we passed the rich fields full of rye, the roadside shrubbery, the grassy slope, the wooden bridge and the fast-flowing river.

*

Sergey had never heard of the process by which one set of colours may be brought to light from underneath another. He listened with scepticism to my description of over-painting, and refused to believe that an antique archangel in vermilion robes lay concealed under the light-blue one.

I resolved to convince him by an actual demonstration. There was no doubt in my mind as to what I should find: it was a classical specimen, with an indisputably antique panel and an oil painting that was just as obviously modern. I knew, too, how easily the oils would yield to the action of the solvent, how they would swell up under the flannel compress, how readily they would come off on to the cotton wool or scalpel, and how bright and clear the picture would shine forth in the area where the compress had been. I was eager to show Sergey this piece of magic, being as certain as any conjuror that the trick would succeed.

Next day, after breakfast, we proceeded to the solemn operation. We laid the icon carefully on the table with the painting uppermost, wiped it with a clean piece of cotton wool, set out the jars and bottles, prepared the scalpel and tweezers, the weight and even a syringe, though there was no need for this as the surface was unblistered. Seeking a good spot at which to apply the compress, I chose the upper part of the picture with the inscription 'Archangel Michael' in Church Slavonic letters. They were somewhat fat and clumsy, and in my mind's eye I could see beneath them the clear, elegant, early inscription, in a slightly different position and on an ochre background instead of a dark-blue one. Imagining all this, I laid the compress over as much of the inscription as possible, confident that under the fat, slovenly letters on the blue background we should in a few moments discover the light, exquisite ones on ochre.

As I expected, the oil painting softened quickly.

'Now, Sergey, pay attention. This is where the trick comes. What do we see here? An oil painting of the nineteenth century. We see the letter 'a', painted in green on a dark-blue background. In a moment – hey presto! We shall see the work of a sixteenth-century master, with the same letter painted in a different style, on ochre, with elegant black strokes. So now: I take cotton wool and make a pad which I dip in the solution, I apply it to the icon and . . .'

The softened-up blue paint and the green 'a' came off as easily as a wet transfer that has not had time to stick comes off a sheet of paper. It was not a question of peeling, but rather of the painting sliding off the surface of the panel. But underneath – horror! – what we saw was not an ochre ground inscribed with an elegant black letter, but a blank white patch of shining gesso.

I could not believe my eyes. At first I wondered if I could have saturated all the layers instead of just the top one, and removed them with too strong and careless a hand. But that was impossible. No, it seemed that instead of my performing a trick for Sergey, Mother Eulampia and her Archangel Michael had played one on me.

I hastily soaked the piece of flannel and laid it on the archangel's robe. Sergey was grinning triumphantly. The only explanation I could think of was that the gesso had crumbled away around the edges of the old icon, and that the restorers had replaced it with the new white ground we had just seen. By laying the compress on the robe in the centre of the picture I should soon find out whether this theory was correct . . . But when a portion of the robe came off, it revealed the same gesso as before. In desperation I applied the compress all over the painting – to the archangel's hands, the background, the nimbus and finally his face. Everywhere the result was exactly the same.

'In short,' said Sergey maliciously, ' "the magician is not at his best today".'

Yes, the trick was a failure all right. But why? The whole thing was utterly ridiculous. Here was a sixteenth-century panel with a nineteenth-century painting on it, and nothing else whatever. It didn't make sense. Nothing under the painting but fresh, new, uncracked gesso – a smug, flat, stupid expanse of white instead of a superb painting. Nothing but the same dreary white wherever the compress was applied.

In a movement of inspiration, or perhaps just of rage and despair, I drove the point of the scalpel sideways into the odious blank surface and gave it a sharp blow. A piece of gesso the size of a three-kopeck piece flew up to the ceiling. The next moment was one of those which, as the saying is, a man remembers to his dying day. The space where the gesso had been was glowing with the rich, even colour of cinnabar. Evidently the modern painter had not applied his colours directly over the old ones but had first covered these with a white ground of his own . . . Working delicately now with the scalpel, I enlarged this opening into the sixteenth century to the size of a square inch or two, and applied the solution to the rectangle thus formed.

I did not know what method present-day restorers used to remove gesso overlying earlier paintings, and it was impossible for me to think of trying to restore such an icon myself. I took it to Moscow, where I entrusted it to expert hands.

It turned out, incidentally, that the modern archangel was upside-down in relation to the early, original one. Evidently, after applying the new white ground the artist forgot which end was which, or he may simply not have cared.

11

WELL, there you are – such is the subject-matter of my story. If I were writing about virgin lands (as I have done), I would keep on using words like 'wheat', 'steppe', 'bustard' and 'tractor-driver'. If I were writing about mushrooms (and I have done that too), I should be using terms like 'russula', 'saffron milk-cap', 'fly-agaric' and so on. Just now, however, I am writing about icons, and it is only to be expected that I should talk about gesso grounds, metal overlay, churches, Boris and Gleb and the Archangel Michael. If one's subject is icons one must describe them.

I am neither a specialist nor an art historian. I should find it hard to give a comparative analysis of the Novgorod and Suzdal schools, to compare the styles of the Moscow Tsars' painters with those of the northern ones or to enumerate the characteristics of the Stroganov style. But since I am writing about icons and constantly mentioning their subject-matter, before relating one or two further episodes in my search for them I think it will be useful if I say a few words about their basic themes, those that were most often treated and are now most commonly met with.

If the reader is bored with this chapter, he is quite free not to read it. For that matter, he may put aside the whole book or throw it away and turn to something closer to his heart, like the construction of gas-mains, or spy-stories, or machine-tractor stations. I myself do not intend to write about icons for the rest of my days: after writing this I shall take up some live, contemporary theme. I may write about a collective-farm

manager (I know a very interesting one), or an historical novel about the time of Vassily III, or, as a sequel to the mushrooms, a small volume on medicinal herbs. But for the present I am going to talk about icons. Of course, a chapter like this is not strictly necessary. But it seems possible that while my reader knows, for instance, that a Venus by Giorgione is not the same as one by Titian, he is not so clear about the difference between the Virgin of Kazan and the Virgin of Bogolyubovo. He may be able to distinguish between a Raphael and a Botticelli Madonna, but be less certain what is meant by 'Elijah in the Wilderness', or 'Elijah's Ascent in the Fiery Chariot', or the Dormition or the Annunciation.

If this is so, and if it is true that not every visitor to the Tretyakov Gallery or the Russian Museum* can distinguish from a distance, without reading the labels, a Nativity of the Virgin from a Christmas scene, or a Presentation of the Virgin from a Purification, or a Virgin *Orans* from a *Hodigitria*, then this chapter may perhaps be of some modest assistance. It always seems to me that it is better to know a little more than a little less, especially on the subject of our own national art which has, moreover, become famous the world over.

I should utter two warnings at the start. In the first place, there are hundreds and hundreds of icon themes. It would be impossible to name them all, let alone describe them. Icons depict all sorts of scenes from the Old and New Testaments, the features and actions of prophets, apostles and saints, innumerable sacred persons in all sorts of groups and episodes. All we can do here is to give some idea of the commonest of these.

Secondly, even if they are on the same subject, all icons differ. No two are identical. It is true that the canons of the art lay down exact rules for the treatment of every theme. For

* Gallery of Russian art in Leningrad.

instance, the Entry into Jerusalem must show Christ riding on a donkey, and there must be trees and buildings representing the Holy City, and crowds strewing garments and palm-leaves under the donkey's feet. And yet, however many icons on this subject we may see, they will all be different, just as a picture by Nesterov or Vrubel differs from one by Repin or Vasnetsov.

Take an even simpler example, without trees or buildings or crowds, say a head of St Nicholas of Myra. This is simply a portrait-type painting, the saint's countenance occupying the whole space of the panel. It is laid down that he must have a beard, and that all the portraits of him must have certain common features, so that a glance suffices to distinguish him from any other saint. Yet all the St Nicholases are different, in the same way as Pushkin's portrait is different according to whether it is by Tropinin, Kiprensky or some later painter.

In this chapter, then, we shall be talking about the canonical themes of iconography and not the artistic qualities of this or that school . . . We may pause here and quote Sevastyan, the peasant icon-painter in Leskov's* story *The Sealed Angel*, who says: 'It's an insult to say that we follow the model slavishly, as if we were just making transfers. Certainly the rules tell us what to paint, but they leave us free to paint it in our own way. For instance, St Zosimus or St Gerasimus must be painted with a lion, but what the lion looks like is a matter for the artist's imagination. St Neophytus has to have a pigeon, St Timothy a casket; the warrior saints George and Sabas have lances, Photius an alms-purse; Kondraty [Quadratus] is shown with clouds, because he made sermons to them. But every icon-painter can depict these things in any way his fancy suggests.'

In the same way, there is a vulgar notion that the rule prescribing canonised subjects fettered the painters' initiative and kept them within rigid bounds, to the detriment of their

* Nikolay Leskov (1831–95), Russian novelist.

talent and free will. This view could only be held by someone who knows nothing whatever about painting. Let me try to explain.

Suppose that a painter, an artist, a master of colouring and composition, line and tone, is set a limit of a thousand themes and forbidden to paint any others. Or, to make it clearer still, let us imagine he is set one single theme and forbidden to depart from it. All this would mean in practice is that he would be precluded from thinking about what may be called the 'literary' aspect of his work; or rather, he would be set free from thinking about it, and would be free to concentrate on the purely artistic or pictorial aspect. Within the limits of a single theme, the composition can be, and is, extremely varied. Our artist would be free to choose his composition, colour-scheme, technique, range and disposal of colours and shades. Being free from the need to expend his talent and energy on the literary, accidental aspects of his work, he could concentrate on solving the purely artistic problems of colour and composition. Instead of painting extensively (i.e. a new subject each time) he would paint intensively, encountering and solving ever-new problems of colour and drawing. And an artist who thus penetrates the depths of his art is bound to reach the heights, perfecting his artistry and attaining consummate skill.

If we now reflect that there was not a single subject only but thousands of them, we shall see that there can be no question of the old artists being enslaved by arbitrary rules. On the contrary, the fact that they concentrated on purely artistic problems may help to explain their achievement – it may even be the reason why all subsequent generations of artists have failed to touch them.

In any case, here are some of the iconographers' themes. The religion they were concerned with was Christianity, and it is natural to begin with representations of Christ himself, who is

usually referred to in the language of icons as the Saviour (*Spas*).

Among what may be called 'portraits' of Christ are the Saviour Not Made with Hands, the Saviour among the Heavenly Powers, the Saviour Enthroned, the Pantocrator and Emmanuel.

The Saviour Not Made with Hands has been seen, if not in the form of an actual icon, by anyone who has seen in a film or opera the Russian warriors of olden time doing battle with the Polovtsians, Pechenegs or other heathens. Usually these warriors carried a standard bearing the image of the Saviour Not Made with Hands. A similar standard is borne by Yermak's men in Surikov's picture *The Conquest of Siberia*. The legend relates that when Christ was carrying his cross to Golgotha a woman handed him a cloth or veil to wipe the sweat off his face. He did so, and the veil became imprinted with his image.*

This icon is generally square or nearly square in shape, with the veil serving as a background. Christ's head is seen without the neck or shoulders: just the face with strands of hair falling more or less symmetrically to either side. The eyes sometimes look full at the spectator, sometimes upward or to one side. Since there are no superfluous details but only a close view of the face, and since in any face the eyes are the most important feature, this type of icon is perhaps the strongest of all in its laconic expressiveness. We may understand our ancestors choosing it for their battle-standards.

* There is another legend relating to this subject which is recorded by St John of Damascus. 'It is known by an ancient tradition that Abgar, King of Edessa, having heard the wonders that were told about Jesus, sent Him envoys to beg Him to honour him with His presence. If this could not be achieved, at least they should bring him a portrait of the Nazarene. And the story says that, as the painter sent by Abgar could not portray on canvas the image of Christ because of the splendour of His face, Our Lord took a cloth, applied it to His divine and life-giving face and sent it to that King who desired it so much.'

The icon which I would place second in terms of significance and expressiveness is the Saviour among the Heavenly Powers. Christ is here depicted full-length, as if seated on a throne. I say 'as if' because the throne is often merely indicated by semi-transparent lines, or not drawn at all. The figure of Christ, wearing bright red or ochre robes with a design on them in gold, is enclosed successively in a scarlet rhombus, a blue oval and a scarlet square, outside which the true background of the icon begins. In the oval are seen the half-transparent forms of six-winged seraphs, and in the corners of the square are the symbols of the four Evangelists: an angel, an eagle, a lion and a bull. White and gold rays emanate from the Saviour in every direction. On his left knee he holds in one hand an open Gospel with a text, usually 'Come unto me, all ye that labour and are heavy laden, and I will give you rest'. The other hand is raised in blessing.

The square, oval and rhombus intersect, overlie and are seen through one another; but, while the square and the rhombus appear flat, the blue oval makes us feel we are gazing into the infinite cosmos, in which the barely outlined, half-transparent seraphim hover about the form of Christ. This is without doubt one of the most powerful and beautiful iconographic themes.

The Saviour Enthroned is a simplified form of the Saviour among the Heavenly Powers. The throne is not merely hinted at with semi-transparent lines but is a real, tangible object like a chair of state: in the early icons it is more conventionally drawn, in the later ones with all kinds of flourishes and orna-mentation. Christ still holds the Gospel and raises his right hand in blessing, but around him there is no oval or rhombus but merely the background of the icon, usually gold or ochre. I may be wrong, but I believe that it was an icon of the Saviour Enthroned which in former days hung over the main gate of the

Kremlin in Moscow, under the tower still called The Saviour's (Spasskaya).

The Pantocrator (Almighty) is a further simplification of the same theme, consisting of a half-length portrait of Christ: he still blesses with his right hand, while with the left he holds the Gospel to his side, the tall volume reaching nearly to his shoulder. If one finds an icon of Christ on a stand in an old woman's home, it is nearly always of this type.

The various developments and simplifications of the theme may be likened to what happens when a film camera is moved closer to the object. We then see the figure of Christ on a larger scale as far as the shoulders, without the book or the gesture of the hands; then, closer still, we see only the head and neck and the beginning of the shoulders. The successive degrees of close-up are denoted by terms meaning 'quarter-length', 'head and shoulders' and 'head alone'.

Another representation of Christ is known as Emmanuel: this shows him as a youth, in quarter-length or head and shoulders, with short hair and no beard or moustache. The expression of the face is quite different, and a person seeing it for the first time would not guess that it was the same Christ. The Emmanuel icons of course resemble one another in so far as they all differ from the full-grown Christ.

Such are the main types of 'portrait' of the Saviour. In addition Christ is depicted in many different ways: in all the acts and episodes of his life, with various accompanying figures and in elaborate scenes. We shall come to these later, but first I must try to give the reader at least some idea of the enormous and varied iconography of the Blessed Virgin, also called the Mother of God or the Queen of Heaven.

The Virgin is depicted in anything up to three hundred different ways, many of which are known by name to most Russians: the Virgin of Vladimir, of Theodore, of Tikhvin, of

the Don, of Smolensk, of Kazan; the Pecherskaya Virgin (of the Cave Lavra* of Kiev); the Virgin of Tolga, Galich, Bogolyubovo, Yaroslav; the Virgin of the Sign, of the Stone Cut Without Hands, of the Three Hands, of the Playing of the Child, the Burning Bush, the Enclosed Garden; the Virgin of Kik, of Korsun; the Jerusalem or Georgian Virgin, the Iberian (Iverskaya); the Virgin of Pimen, of Belozersk, of Murom, of Sedmiyezersk, of Shuya; the Petrovskaya, Vsemirnaya (Universal), Strastnaya (of the Passion), Tsargradskaya (of Constantinople), Rimskaya (of Rome), etc., etc. – numbering in all, if not three hundred, at least two hundred and fifty. However, this profusion of themes can almost all be ranged under three main types of composition, known respectively as the *Eleousa*, the *Hodigitria* and the *Orans*. Let us examine the meaning of these mysterious terms.

As to the *Eleousa*, Antonova and Mneva write as follows in their *Catalogue of Old Russian Painting* (vol. 1, p. 61): 'This type of composition, known in Byzantium as the *Eleousa* (Merciful) is called *Umilenie* (Tenderness) in Russian. This term exactly renders the iconographic content of the picture: the child's loving attitude towards his mother and her foreknowledge of the sufferings that await her son. The composition was devised in Byzantium in the eleventh century. A favourite version was that in which the Virgin, who is seen in half-length, holds in her arms the child, who lays his cheek against hers. Her head is bent towards the child, which she supports while the child embraces her neck in a passionate gesture.'

If, therefore, you see an icon of the Virgin and Child in which the child presses his cheek against his mother's, you may be certain that it belongs to the *Eleousa* type; but it is still a question which of the dozens of possible variants it represents.

* Monastery.

The best-known of these is doubtless the Virgin of Vladimir, which Igor Grabar called 'our most ancient hymn to motherhood'. Among the many others may be mentioned those of Kik, Korsun and Yakhroma. The difference may depend on which of the Virgin's arms supports the child and consequently whether he is touching her right or left cheek. The child's attitude, the position of his body and feet, the angle of the mother's head, the way she holds the child and the details of her clothing – all these features are prescribed in the canon and determine the correct designation of the icon.

As my readers certainly know, the original Virgin of Vladimir is now in the Tretyakov Gallery, while variants of different sizes are in existence all over Russia, and are equally entitled to the name of 'Vladimir'. Similarly the principal 'Fyodorovskaya' is, I believe, at Kostroma, but in this case the original was stolen at the beginning of the present century and has never been recovered.

The second type of composition, the *Hodigitria* (Guide, Indicator of the Way), is represented by the Virgin of Kazan. Here the child, held in its mother's arms, does not touch her cheek or look towards her but sits in a detached position and gazes to one side or towards the spectator. Other icons of this type are those of Smolensk and Tikhvin, the Georgian, Iberian and Pimenov.

The third type is called the *Orans* (the Virgin in Prayer), or the Virgin of the Sign. The Mother of God is depicted frontally, in half-length, with her hand raised to shoulder-level and turned towards us. Emmanuel, also half-length, is depicted within a circle on her breast, or sometimes simply against his mother as a background.

I would emphasise once again that this is only a bare outline: every icon, of whichever type, shines, glitters and burns with pure bright colours and possesses its own unique character,

expressiveness and fascination. Here, for instance, is another and fuller description of a Virgin *Orans*:

The drawing and composition are exquisite and harmonious. The elaborate colour-scheme is a combination of rich, subdued tints with the brilliance of the nimbuses and the uniform, radiant gold of the background. The olive-tinted *sankir* (flesh-colour) is coated with dark ochre, with highlights in yellow, and barely discernible touches of rosy pink. The Virgin's cloak is reddish-brown with a well-marked edging, stars and a fringe. The folds are picked out in brown. The headgear and chiton are dark green with matching highlights. The child's undergarment is greenish-white, with a pattern of green dots and gold leaves. His chiton is ochre with gold hatching; the scroll hanging down is white. The nimbuses are of a bright coral-pink shade . . .

This is the description of an *Orans* of 1530, in the Tretyakov Gallery, by Antonova and Mneva (op. cit., vol. 2, p. 24).

Sometimes the Virgin *Orans* is shown full-length, and she is then called *Panagia* (the All-Holy One). Without doubt, the prototype of all Russian icons of this type is the Virgin of the Immovable Wall in the cathedral of the Holy Wisdom at Kiev.

The Virgin of Bogolyubovo: the twelfth-century original is at present awaiting restoration in the central workshop in Ordynka Street in Moscow; it is feared, however, that there may turn out to be little left of the original under the successive additions. Variants of different dimensions, age and quality of workmanship may be found all over Russia, though the subject was chiefly treated by the Vladimir-Suzdal and Moscow schools and hardly at all by those of Novgorod, Pskov and further north. In this icon, the Virgin is seen full-length on the left of the panel, facing a group of people who are prostrating themselves on the right, with others standing behind them. The composition of these groups varies a great deal: they often include Prince Andrey Bogolyubsky, St Sergius of Radonezh, male and female martyrs and bishops. In the upper

right-hand corner the Saviour is seen blessing the Virgin. In the storeroom of the Suzdal museum I have seen a small icon of this type which exactly reproduces the architecture of the old parts of Bogolyubovo.

There are also very elaborate compositions with the Virgin as the central figure, with such titles as In Thee Rejoiceth, Joy of All that Mourn, the Burning Bush, Joy Unforeseen, and so on. These are symbolic representations of church anthems and the like; they contain a great many different characters and are not easy subjects for description.

The Virgin may be regarded as the most popular and venerated object of devotion among the pious folk of old Russia; not a hut, not a shrine was without her image. But if there is any saint who can be said to have held his own with her in popularity, it was without doubt St Nicholas of Myra. It is a puzzle why this bishop from Asia Minor should have appealed so strongly to the Russian faithful, why his intercession was considered so powerful and his ear so ready to harken to prayers. Here are three of the chief themes associated with him.

Most frequently he is seen as a portrait head or quarter-length figure. If he is shown half-length he generally holds a book with a Gospel text, though sometimes it is closed. He has a short, curly beard and a high forehead with bald temples, and may be recognised by his bishop's robe, the *omophorion*. This is nearly always white, with large black or red crosses on the shoulders.

'St Nicholas of Zaraisk' is shown full-length, holding a book in his left hand and blessing with the right.

'St Nicholas of Mozhaisk' is one of the most interesting themes. He is seen full-length, holding in his left hand a 'town' resembling a church or monastery, while in the right he raises a sword – thus typifying his role as protector of Russian cities and sacred buildings. This composition is also called 'Nicholas

with the Sword and City', and one sometimes comes across it in the form of a wood-carving.

All these three types of St Nicholas, especially when executed on large panels, are often surrounded by small scenes depicting the saint's life. This also occurs with other saints, in particular St George, St Sergius of Radonezh, St Paraskeva (Pyatnitsa) and the martyr St Barbara, but it is more frequent with St Nicholas than with any others. Icons of this type are especially decorative and interesting to the collector. The main figure of the saint, in the middle, occupies the greater part of the panel, and the margin all round is divided into sections, each showing a different episode. These individual scenes may at other times be the subject of icons in their own right. Here is a list of the scenes to be found on an icon of St Nicholas belonging to the Rostov-Suzdal school of the late fourteenth century, and now in the Tretyakov Gallery: the saint's birth; he is taken to school; he is ordained deacon; he is consecrated bishop; he saves sailors from drowning; he appears in a dream to the Emperor Constantine; he saves Demetrius from the bottom of the sea; he delivers three men from execution; he drives devils out of a well; he delivers three prisoners; he buys a carpet; he gives it to the wife of a holy man; he saves Basil, the son of Agricus; a miracle involving a girl; the saint's death; the translation of his relics.

*

Representations of the Prophet Elijah (Elias) fall into two types, the Prophet in the Wilderness and the Fiery Ascent. Both may or may not be accompanied by small scenes of his life.

Elijah in the Wilderness: in the foreground are rocky hills and withered shrubs. The Prophet sits in front of a dark cave and is listening to something. A stream flows at his feet, and there is a pitcher beside it. In the right upper corner is one of

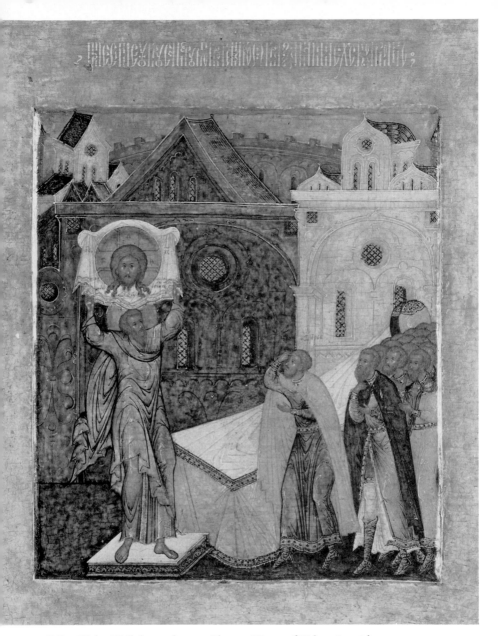

'The Holy Veil brought to Abgar, King of Edessa', 16th century

the ravens which, according to the legend, brought Elijah food.

In the Ascent we see a cloud of fire, and in it a chariot drawn by horses with flames streaming from them. In this chariot the Prophet ascends to heaven. He is always shown casting a fur-lined cloak down to his disciple Elisha (Eliseus). This icon, with the sea of fire and the fiery horses, the azure sky and the bleak desert hills, and Elisha clutching at the mantle, is highly artistic and expressive.

Half-length 'portraits' of Elijah are also found in the early period, but later ones are rare. He is shown with sloping shoulders and thin strands of flowing hair, a long narrow beard and drooping moustache.

*

The Great Martyr St George, known also as St George the Victorious, and to the Russian people as Yegory, is depicted in two ways; either as a foot-soldier in warlike garments with a lance and sword, or on horseback slaying a dragon, in which case the icon is also called The Miracle of St George.

I do not know any more attractive icon for a collector than this one, in which imaginative and pictorial qualities are combined with noble and majestic symbolism. Of course an icon of Elijah in the Wilderness or the Saviour Enthroned may be beautiful, but apart from painting and religion as such there is no symbolism to which the human soul responds more readily than that of St George. The monster with its terrible fangs has devoured one beautiful maiden after another, and now it is the princess's turn. Just as she leaves the city gates and the dragon advances towards her, a youth appears from nowhere on a white horse and, with his red cloak fluttering, drives his lance into the monster's jaws: so justice is done and the maiden saved.

There are variations on this theme. St George sometimes

I 129

carries a lance, sometimes he brandishes a sword over his head. Sometimes the icon shows only the saint, his horse and the dying monster; at other times there is a six-cornered tower representing the town, with the king and queen standing at the top and their daughter at the gate below. I have even seen one with a ladder leaning against the tower and a frightened townsman scaling it with all speed.

The horse may be white, but is occasionally black; I have seen red ones in Bulgaria, where a composition of this type is used for icons not of St George but of St Demetrius of Thessalonica, who is striking down not a dragon but the monarch Kaloyan. In Russian iconography St Demetrius is shown full-length, carrying a *tavlion* or cloak and moving from right to left.

The Miracle of St George and the Dragon is seldom accompanied by scenes of the saint's life, but the following may be seen on a sixteenth-century specimen in the Tretyakov Gallery: St George preaching to Diocletian; he is scourged with ox-sinews; he is tortured with hooks; he preaches in prison; he gives away his property; he is broken on the wheel; he restores her young son to a widow; he destroys idols; he is tortured with iron implements; he is boiled in a cauldron; he brings to life a bull belonging to the farmer Glykery; his last miracle; he is cast into a lime-pit; he brings the dead to life; pagans embrace the true faith; beheading of the Empress Alexandra; beheading of St George; St George, in a dungeon, converses with an angel.

Collectors are especially fond of icons depicting horses. I remember one who was trying to sell me a Nativity and kept repeating: 'Come on, don't be stingy, it's got six horses apart from everything else!' If one takes this attitude, the most valuable icons ought to be those showing the Miracle of Saints Florus and Laurus. The legend relates that some herds-

men had lost their horses and turned for help to these Saints, who appealed to the Archangel Michael, so that the herd was immediately found. All this is seen on the icon, with the herdsmen on horseback and the rest of the animals galloping from left to right across the bottom of the picture. The Archangel, Commander of the Heavenly Hosts, is also seen on a fiery steed; he has a ruddy complexion and waves his fiery-red wings. In one hand he holds up the Gospel and in the other a censer on a chain and a small cross. In this hand he also holds a lance with which he smites the devil writhing at his feet. His two raised hands are joined by a rainbow. The horse is galloping over a dark abyss into which blazing towns are falling, while the Archangel blows a trumpet.

Other icons depict the Archangel full-length, in red robes, with a lance in his hand. There are also paintings showing only his head, e.g. a valuable icon in the Russian Museum known as the 'Golden-Haired Angel'.

*

A special category of icons, also popular with collectors, are the Festivals or feasts of the church. It was customary for twelve of these to figure on the iconostasis, where they formed a separate row, but the actual number is much greater. They include the Annunciation, Christmas, the Presentation or Purification, the Baptism of Christ, the Entry into Jerusalem (Palm Sunday), the Transfiguration, the Protection or Intercession of the Virgin, her Dormition or Assumption, the Elevation of the Cross, Christ's Resurrection and Descent into Limbo, the Trinity, the Presentation of the Virgin, the Ascension, the Crucifixion, the Women Bearing Spices, the Raising of Lazarus, the Nativity of the Virgin, the Descent from the Cross, etc., etc.

The Annunciation: the Archangel Gabriel declares to Mary

that she is to give birth to the Son of God. Gabriel is seen on the left of the panel, Mary on the right. There may be a building of some kind, and also a ball of yarn; Mary was spinning when the angel visited her.

Christmas (the Nativity): a theme of great beauty which may be either simplified or elaborated – this is true of the other subjects also, but especially of this one. The Virgin lies in the centre of the picture in front of a cave, and beside her is the Child in a manger, with the ox and the ass standing close by. This is the basic theme, but the icon also shows the star over Bethlehem with the Magi adoring the Infant; the Child being washed, the midwife Solomia, a shepherd tending his sheep, St Joseph seated on a rock, and the Devil, in the form of an old man, tempting him. We may also see King Herod's soldiers slaying the Innocents, and the flight of the Holy Family into Egypt.

The Dormition [in Russian *Uspenie*, Falling Asleep] of the Virgin: she is seen lying on her back in the centre of the picture, her hands folded on her breast. The Apostles stand to right and left of her, six on each side. Bishops and women of Jerusalem are sometimes seen behind the Apostles. Christ stands beside his mother, bearing away her soul in the form of a child. The upper part of the panel is usually occupied by buildings representing Jerusalem.

A figure who may be present in the scene is Athonius, who, wishing to insult the Virgin on her death-bed, stole up to overturn it; but, as he was stretching forth his arm, an angel appeared with a sword and cut off both his hands. The icons often illustrate this precise moment: the angel's sword has swept, Athonius's hands are seen separated from his arms, the blood flows . . .

The Baptism of Christ: the Saviour stands amid the waters of the Jordan, while St John the Baptist lays a hand on his head.

A bright ray from heaven, signifying God's blessing, falls upon the Saviour.

The Presentation of the Saviour in the Temple: on the right-hand side, in the church porch, stands St Simeon, bending forwards. Facing him on the left are the Virgin, St Joseph and Anna. The Virgin presents the child to Simeon, who receives him into his arms.

The Resurrection, or the Descent into Limbo: the legend relates that Christ's first action after his Resurrection was to descend into limbo to liberate the souls of our first parents, Adam and Eve. The icon represents Christ triumphing over hell. He is seen in a 'glory', standing in front of the ruined gates of hell and drawing Adam and Eve forth by the hand. (A 'glory' is the term for the oval, or sometimes round, shape enclosing the figure of Christ or the Virgin; it may be pink, green or gold.) At Christ's feet is a broken chain, pincers and various small instruments of torture. The righteous men and women of the Old Testament are released, while the demons are harried by angels.

One of the brightest Festivals is the Entry into Jerusalem, which I described at the beginning of this chapter. I will, however, quote an account of a particular icon in the Tretyakov Gallery, belonging to the Moscow school of the mid-fifteenth century:

Christ, seated sideways on a white horse which here replaces the donkey, is seen riding towards the right of the picture and looking back at seven Apostles who are following him on foot. Children are strewing garments and branches under the horse's feet, and the people of Jerusalem are advancing to meet Christ from their tall city of stone . . . A mountain rises behind Christ, as far as the top left-hand corner of the panel. A tree extends leftward from behind the city walls, and three children dressed in white can be seen amid the foliage, breaking off branches. (*Catalogue of Old Russian Painting*, vol. I, p. 315.)

The Transfiguration: Christ is seen in the centre, usually on a mountain, in white robes and in a 'glory'. Three sharp rays like sword-blades descend obliquely from him so as to touch the Apostles Peter, James and John, who have fallen to the ground bedazzled, or perhaps terror-stricken.

Protection or Intercession (the word also means 'covering' or 'cloak'): the Virgin, sometimes in a 'glory', stands in the upper centre of the picture on a small conventionally-rendered cloud. Behind her is a church with many domes. She holds a veil or mantle which she extends protectively over the figures in the lower part of the panel. These may include bishops, apostles and holy men, and the Deacon Romanus is always among them.

Sometimes we find icons commissioned by private customers. A merchant, for instance, would come to the icon-painter and ask him to do an icon of the Intercession: if the merchant was called Aleksey and his wife Catherine, then we may be sure to find among the figures St Alexis the man of God and St Catherine the Great Martyr.

It is frequent for several Festival themes to be combined on a single panel. In that case the Resurrection will be depicted in the centre, and the other scenes in roundels at the top and bottom and on both sides. Such an icon will always be named after the main, central picture. The reader may remember our search at Prechistaya Gora for a Resurrection icon from the old monastery: this, which we failed to find, was one of the kind with the other principal Festivals inscribed round it. In such cases they are always done in miniature. I have one in my collection at present: it measures no more than twenty by six-teen inches, but there are no fewer than thirty-eight pictures on it.

Here I must refer once more to Leskov's *Sealed Angel*, where

the talented Sevastyan paints an icon of miniature Festivals for an Englishman, who orders them for his wife's benefit.

'So as to show me what you can do, let's see you paint an icon for my wife in the old Russian style.'

'On what subject?'

'It doesn't matter; anything you like that will please her.'

Sevastyan thought for a bit and said: 'What does your wife pray for most?'

'I don't know, my friend, but I fancy she prays most that our children will grow up into decent people.'

Sevastyan thought again and said: 'Very well, I'll make something suitable.'

'How do you mean, suitable?'

'Something fit for contemplation, something that will fortify the spirit of prayer in your good wife.'

The Englishman gave orders that everything Sevastyan needed was to be set up in his own quarters; but Sevastyan would not work there, he preferred to paint by the attic window. And he produced a picture, my friends, that none of us could have dreamed of. Because of the children we thought he would make an icon of St Romanus the Wonder-Worker, to whom women pray for fertility, or the Massacre of the Innocents, which always consoles mothers who have lost their children, because Rachel mourns with them and will not be comforted. But this wise painter, reflecting that the Englishwoman had children and was praying, not for more of them but in order that they might be virtuous, decided on something quite different and better suited to her ends. He took an old tiny piece of wood no bigger than the palm of one's hand, and exercised his skill on that. He began by preparing it well with good Kazan alabaster, so as to make a strong smooth ground like ivory, and then he divided the wood into four equal spaces, each for a different icon. He even made the spaces smaller by putting a gold border round each one. And then he began to paint.

In the first space he painted the Nativity of St John the Baptist, showing the room and eight figures besides the baby; in the second, the Nativity of the Virgin, with the room and six figures besides the baby; in the third, the Birth of Our Lord, with the stable and manger and the Virgin and St Joseph, and the Wise Men and Solomia the midwife and all manner of beasts: oxen, sheep, goats and asses . . . And in the fourth space was the Birth of St Nicholas, and here too

135

was the hall of the palace and the child and many figures besides. And how full of meaning it was to see those who had care of such holy children, and with what art they were shown, all so tiny, yet full of life and movement!

In the Nativity of the Virgin, for example, there was St Anne, as the Greek model instructs us, lying on a couch, with girls in front of her playing on tambourines, and others bearing gifts, or a sunshade or candles. One woman supported St Anne by the shoulders; St Joachim was gazing at the roof of the palace; the midwife was washing the Virgin, who was up to her waist in a tub of water filled by a maid whom we could see to one side. The rooms were marked out as if by a rule, the upper chamber bluish-green and the lower one purplish-red, and in this one we saw St Joachim and St Anne on a throne, and St Anne holding the Blessed Virgin, and all round the palace were stone pillars and vermilion curtains and a white and ochre balustrade . . . Sevastyan painted all this in a wondrous style, and in every tiny face he expressed the bliss of seeing God, and he called his work The Holy Children, and he brought it to the Englishman and his wife.

They looked at it and were astounded – they said they had never expected such fantasy, such microscopic precision, and they looked at it through the magnifying glass and could find no fault in it. They gave Sevastyan two hundred roubles for it and then said: 'Could you do a smaller one still?' And Sevastyan replied: 'Yes, I could.'

I do not know what anonymous disciple of Sevastyan's from our Vladimir township of Mstyora painted a triptych that I acquired recently and that won a prize at the Paris Exhibition of 1898. It was painted for that occasion and is said to have taken the artist two years. The panel is no larger than that described by Leskov, and on it he has managed to paint not four but forty-three scenes, as well as fifty saints around the edges.

*

I should now describe the special kind of group known as a Deesis, and also what is meant by a 'tier' or 'order' [*chin*,

literally 'rank']. This term means a row of icons forming part of the iconostasis, each one being complete in itself but the whole forming a homogeneous set, e.g. the Festivals. A 'Deesis tier' is a set of icons composed as follows. The central one represents the Saviour among the Heavenly Powers, or the Saviour Enthroned. On his right, i.e. the left as we see it, is an icon of the Virgin, and on the other side St John the Baptist. Beyond them, still on either side, are the Archangels Michael and Gabriel. All these figures are turned with faces and bodies towards Christ, so that Michael always appears facing our right and Gabriel our left. Outside these, similarly disposed, are St Peter and St Paul. The symbolic meaning of the Deesis [a Greek word meaning 'entreaty'] is that Christ on his throne is preparing to judge mankind for their sins, while the other sacred figures beseech him to be merciful. [Deesis is corrupted in Russian into *Deisus* by analogy with *Iisus*, Jesus.]

The basic and simplest form of Deesis is a triptych consisting of the Saviour, the Virgin and St John. At the other extreme, any number of figures may be added at each side: archangels, apostles, saints, bishops, prophets, martyrs, etc. The figures may be full-length or quarter-length or consist of heads only. They may be depicted on one panel or on several, but the order is always the same: the Saviour in the middle, the Virgin and St John, two archangels, two apostles and so on.

In the Tretyakov Gallery there are some icons from a Deesis tier painted by Andrey Rublev and Daniel Cherny for the church of the Dormition (*Uspensky Sobor*) at Vladimir. They are enormous in size, and we may imagine the effect of the whole tier as part of the majestic iconostasis of that majestic church.

Where does the Deesis figure in the iconostasis, and is there

any fixed rule about the composition of an iconostasis as a whole? There is, and quite a detailed one. Firstly, in the centre of the iconostasis are the 'Royal Doors', which in early times were painted with icons, though of a somewhat different design. The doors were a work of art of a particular kind, in which wood-carving and sculpture played a part as well as painting. Here is Antonova's description of a pair of Royal Doors of the Vologda school of the early sixteenth century which formed part of the collection of the late Pavel Dmitrievich Korin.

The elongated panels of the two-leafed doorposts are surmounted by a six-lobed palmette with spiral flourishes. At the top is the Annunciation, showing the angel descending and Mary at her spinning-wheel facing him. Both these figures, in expressive attitudes, are dressed in subdued green and brown shades against a background of pink, scarlet, silvery-green and golden-yellow buildings, the style of which is full of elegance and fantasy. To Mary's right are two dark-green capitals in the shape of lions' masks. The light tower-like structures behind Gabriel seem to be in a recessed position, while the more massive ones behind Mary, with their round or pointed tops, seem to crowd her in, especially on the right-hand side. The Evangelists, sitting on low benches, have elongated torsos; their attitudes are calm and majestic. The massive St John turns to one side as he dictates to Prochorus; St Luke, with curly hair, opens a book; St Matthew, with a long beard, unfolds a scroll; St Mark writes, bending over the parchment. St Luke is identified by a golden strip running the length of his garment. The architecture of these icons is quieter than that of the Annunciation; the dark embrasures facing the centre concentrate attention on the Evangelists' unhurried gestures. The scene on Patmos is enhanced by the highlights on the yellowish-olive mountain with its two peaks: it appears to be bathed in light, towards which the inspired Evangelist turns his face. The colours are pure and strong, with combinations of scarlet, pink, yellow, turquoise blue, grass-green and blue-green hues and shades of coral red.

The Royal Doors, then, are in the centre of the lower part of the iconostasis. The remainder of the screen at this level is

occupied by large icons on various themes, one of which must be that of the saint or feast to which the church is dedicated (cf. Notre-Dame in Paris, St Paul's in London, the church of the Protection on the Red Square, that of the Assumption in the Kremlin, St Nicholas's at Khamovniki, St Isaac's and the Kazan Cathedral in Leningrad, etc.). Above this row is the narrow tier of Festival icons, which are always cheerful and decorative: as we saw, they include the Assumption, the Nativity, the Presentation, the Resurrection etc. Above the Festivals is the Deesis, extending to the full width of the iconostasis, with the Saviour directly above the Royal Doors. Of course, in practice there are deviations from this rigid order, but this is the traditional arrangement.

Now that this chapter has already run on too long, I see that I have attempted an impossible task. Although I observed at the outset that there were hundreds and hundreds of icon themes and that it was impossible to enumerate, let alone describe them, I had imagined that it would be possible to say more. I have had to omit the whole iconography of St John the Baptist, St Barbara and St Paraskeva, Saints Peter and Paul, Cosmas and Damian, Constantine and Helen, St Panteleimon the Healer, St Christopher, the Elevation of the Cross and the Vision of the Blessed Eulogius, the Holy Wisdom (Hagia Sophia), the theme 'Mother, Weep Not for Me', the Women Bearing Spices, the Old Testament Trinity, the Last Judgement, the Miracle at Cana, 'Wisdom hath Builded her House', the Blessing of Many Children, the Forty Martyrs of Sebaste . . . Need I go on? As I said, it is impossible even to name them all.

All these, moreover, are only the themes that have come to us from Byzantium: later we in Russia had our own saints, and our own icons of them; Boris and Gleb, Sergius of Radonezh, Basil the Blessed, Cyril of Belozersk, Aleksandr Nevsky,

Vladimir and Olga of Kiev, the Tsarevich Dmitry who was murdered at Uglich, Serafim of Sarov . . . But for the sake of moderation I must stop. For anyone who is still not interested in the subject, the main lines will be quite enough, while anyone who is will get hold of a book on iconography.

12

MANY a time, returning from an unsuccessful quest, I have tried to calm my bitter disappointment by repeating some lines by Vassily Fedorov* to the effect that 'the hunter knows the sable is there, and that is enough for him': meaning that he is certain to catch it in due course, once having hit upon its trail and its approximate whereabouts. But there is another way of looking at it: 'Seeing is one thing, and having is another.'

In the story about the old woman at Volosovo monastery and the Archangel Michael, we may say that the poet was right. I dreamt of the 'sable' for two whole years, and as the icon existed I had some ground for hope that some day, somehow it might become mine. But how many other 'sables' have I had to pass by without the slightest hope that I should ever catch them!

I remember once, passing through a small hamlet, I was told that it had previously ranked as a village and had contained a chapel with one icon in it: that icon was now in the possession of 'Uncle Feofan', whose house the inhabitants pointed out to me.

There proved to be some difficulty in approaching it, as there was a large apiary alongside, and the warm summer air was filled with the nervous, angry buzzing of bees darting in all directions. Evidently the old man had been ransacking the hives for honey.

Uncle Feofan, as befitted the owner of a bee-garden and the only icon in the village, was an old-timer with white hair and

* Contemporary Soviet poet.

a patriarchal beard. He would have looked the part of a traditional peasant even more completely if his hair had been parted in the middle (and a comb stuck in his belt), but in fact it was tousled and untidy. Nevertheless he bore a strong resemblance to the soothsayer who is seen with Prince Oleg in Vasnetsov's picture.

For some time now, when I go to visit a stranger, particularly on such a delicate mission as this, I have been in the habit of showing documents to prove my identity. I have heard rumours that there is a swindler who goes about with forged papers impersonating people and obtaining icons on false pretences. Russian country-folk are a good-hearted and trusting lot. I realise that even if I do show my documents and prove who I am, it will not prevent some rogue with a smooth tongue from coming along and pretending to be a writer, and being believed. But in any case, whenever and wherever I get into contact with people on my quests, I always insist that they look at my papers to show that everything is above board.

So I produced them now for Uncle Feofan, but instead of studying them he took me into the house and gave me some fresh lime-blossom honey. He was friendly, but at the back of his eyes there was an expression of wariness, apprehension and mistrust. After all, I might suddenly brandish my papers at him (how could he tell what they did or didn't prove?), declare that I had orders to confiscate the icon, and be off and away before he knew what had happened . . . And it was clear that he kept the icon as an object of worship: there were candles in front of it with wax dripping from them, and a big silver lamp hanging on three chains. The icon was 'clothed' with plates of copper, behind which I saw – heavens above! – St George the Victorious on horseback, and the tower, and the princess coming forth, and the lance transfixing the dragon's jaws. If Uncle Feofan had told me at that moment that I could have the

icon if I would let him chop off one of my fingers, I would have laid it on the block instantly . . .

He had kept the icon at first in the hope that some day there might again be a chapel in the village where it could be re-instated with due ceremony. But now he was growing old, and he simply kept it for its own sake.

I finished the honey; it was time to part from St George the Victorious, but how could I do so without making some attempt, however hopeless I knew it to be?

'Uncle Feofan, have you ever thought of selling that icon – say, if you were paid quite a lot for it?'

'I'd be glad to sell it, I need money. But it's not mine, it belongs to the commune. It's only here for safe-keeping. You'd have to ask the commune.'

'Tell me who it is and I'll ask them.'

'I don't know who you could ask now. There's no-one to ask.'

'Then if there's no-one to ask, you can decide yourself.'

'No, I can't. It belongs to the commune. I only took it to look after, I can't sell it of my own accord.'

'But there's no commune and nobody to ask any more. If you can tell me anyone to ask, I'll ask them.'

'I'm sorry, I don't know. There's nobody to ask.'

'Then tell me whether I can have it or not. I'll pay you all it's worth.'

'I'm sorry, friend, it's not my icon. It's a trust from the commune.'

I left the old man, vexed by his stupidity, and saw him standing on the threshold with his long beard, like the wizard in the picture. I wonder if it was he who sent four bees whizzing after me – three got mixed up in my hair, and the other found a tender place to sting, just below my left ear.

*

In another village, knowing that it was a place of some antiquity, we decided to go round the houses asking if there were any old-fashioned objects stored away. The foreman at the collective farm – a young man, almost a boy, but married – met us outside his house: he was a little drunk. He held my hand in his for a long time, gazing into my eyes and beaming as if he had met an old friend; then he said: 'I believe you're not Slavka after all.'

'No, I'm not. We're strangers in this village. Here, have a look at my papers.'

'No, I won't, not on any account,' he replied, ostentatiously turning away from them. 'I'm not a policeman, I trust you anyway. This is part of a collective farm here, but I have my own set-up. Anything I can do for you – just say the word.'

'Still, you might as well look at my papers, just to be on the safe side.'

He turned away still more decisively, so as not to see the papers even with the corner of his eye. 'No, I won't, and that's flat. Put them away.'

'Just as you like, then. We wanted to ask you something . . .'

We explained our purpose; he listened with concentration, like a general preparing an attack.

'Right. We'll see what's best to do. We'll begin with my own people.'

The foreman's married sister invited us into her sitting-room.

'Come on, Antonida, let's have the icons down and find out which are the artistic and historical ones,' said her brother in a tone of command as we crossed the threshold.

'Perhaps we should handle things more gently,' I whispered to him. 'We haven't come to take them away, just to look at them. If we like one, we can ask the people whether they'll sell it.'

He smiled indulgently at my simplicity. 'Don't you think I

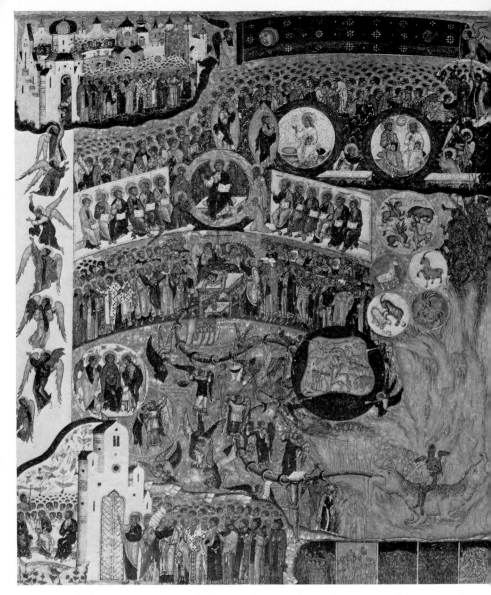

'The Last Judgement', late 16th or early 17th century, Moscow (Stroganov)

know my own villagers? They each have to be treated differently.'

Antonida had no antique icons, but she had a Virgin of Kazan that we liked the look of: it was painted in the nineteenth century, but in a handsome style.

'Will you sell us this one?'

'Oh, dear. Oh, dearie me. It's a remembrance from old Masha Volchonkova.'

'Was she a relation of yours?'

'She was our neighbour – they were kulaks, and a cart came one night to take them away. It was winter, there was a snow-storm blowing. They bundled the children and all into a sledge and that was the last we saw of them. Aunt Masha rushed round to say goodbye; she fished this icon out from under her coat and said: "Here, keep it; it'll remind you of me." So I've kept it, and every time I dust it I think of her.'

Sure enough, the foreman had a special approach to every-one. In another house he said: 'Well, Granny, open up, let's see what old things you've got.' He had grasped at once what we were looking for, and to another old girl he said: 'Come on, it's no use showing us all this new stuff. Haven't you got some old icons in the attic that are quite black, with only just the faintest trace of a picture?'

We went round almost the whole village with him. He had kept his eyes open, and he was anxious to do us a good turn. Moreover he shared our sense of adventure, and soon entered into the spirit of the chase. We came to the next house – not the next physically, but next in the foreman's strategic plan.

'Pelageya, open the door, we've come to look at your icons.'

'All right, come and look if you want to, but it's dark in here.'

Pelageya was by no means an old woman, but her home

certainly looked dingy. Apparently she had lost her husband in the war, or he had fallen ill and died, and she had gradually lost interest in life and neglected the housekeeping; all days were alike to her, and anyway she was out at work all day long.

As soon as I looked at the 'front corner' I felt an odd sensation, a 'cardiac murmur' as my medical-student friends would say. There was a heap of ordinary icons on a shelf, but there was one which was distinguished first of all by the fact that the metal overlay covered the edges only: in the centre was a large black shape which I knew to be that of a head of the Saviour. The face could hardly be seen: in our guide's words, it was 'quite black, with only just the faintest trace of a picture'. What is more, the picture must have been painted by a great artist. The Saviour had a curious, almost sullen expression: bitterness, pain, reproach and something like contempt could be felt in the grave, accusing look and the downturned corners of the mouth. 'What have you to say for yourselves? I taught you, I suffered torture and a cruel death for you, and what have you done in return, miserable people that you are!'

To render Christ's features in this way is of course contrary to the essence of his teaching and his attitude towards human beings: the whole point of Christian doctrine is that one should not upbraid or take offence, still less despise one's fellows. Nevertheless, such were the feelings this artist had chosen to express in the face of the suffering Christ.

Now, as usual, we had to tread warily. Three stages had to be gone through before we could talk business with the icon's owner.

Firstly, one is not always allowed to take the icon from its stand. On this occasion we were, which was already a point gained.

Secondly, it is important to be allowed to take off the metal plating, so as to examine the picture and panel and also because

146

once the plating is off, the owner is less reluctant to part with the icon. In fact they nearly always agree to its being taken off: the owner becomes curious to see what is underneath, and will fetch her sugar-tongs to help you bend back the metal and pull out the nails. So the plating comes off, to reveal the surface covered with cobwebs, dust and dried-up flies. The owner offers to wipe the icon with a damp cloth, but this will not do: damp would be fatal to it. So you stay her hand with a reproving gesture, and in this gesture there is already a hint that you are the master of the icon, now that it has been taken out of the frame and stripped of its metal overlay.

The moment you utter a word about selling the icon, its God-fearing owner is up in arms. Sometimes you sense that her resistance may be overcome; at other times intuition tells you that however much you argue and persuade, nothing will come of it. Usually the more loud and violent the owner's indignation at the outset, the more chance there is of her yielding. But if she says quietly: 'No, my dears, I can't give it to you', then that is the end of the matter.

It was in this calm tone that Pelageya said: 'It has my mother's blessing on it. If I were to give it up I'd have nothing left – just the empty hut. When my time comes to die, you can have it.'

The foreman was apologetic. 'We gave the show away, letting her see how much you were interested. Lots of times I've been into her house when she's left the doors open while she chattered to the woman next door or pottered about in the garden. I could just have taken the icon and sent it to you by post, if you need it so much. But now she knows what we're up to, it's no good thinking about it.'

We could see in our friend's face that he had not quite given up the idea of stealing the icon, and before leaving we impressed on him severely that if it were stolen we should have to bring it

back, and word of the theft would get around. We parted, if not as old friends, at least like old acquaintances: in fact we felt very much like cementing the relationship with a drink.

<p align="center">*</p>

In a third village – but why do I say a third, it was probably a twentieth, thirtieth or fortieth – we stopped by instinct at the very last house and found out after five minutes' chat that 'Aunt Pasha' had a real wonder-working iron that had been saved from the church when it was destroyed. It might, of course, prove to have no value as an antique or a work of art, and even if it was a Rublev there was no guarantee we could lay hands on it, but obviously we should not miss the chance of seeing a wonder-working icon.

Aunt Pasha's house was locked. Her neighbour, scraping carrots on her own doorstep, said: 'Go round the back, I should. She went off with a sickle to cut some potato tops.'

When Aunt Pasha saw us walking towards her across the field, she stood up straight and waited till we came up and explained our business. She was not old but somewhat withered, as if she lived without enough sun or air. She came quite willingly to the hut with us, casting sidelong glances as if to say 'Well, this is peculiar – young people like this, interested in icons.' As we went along she told us the story of her treasure.

'It appeared one day by a spring that comes out of the ground in a deep ravine there, between the two villages. Beautiful clear, cold water it is. Just around it there's a clearing, and then there's sedge and white flowers with a lovely smell. It's a beautiful place, all fresh and clean. Well, the icon was found there by a boy of nine, and as children were well brought up in those days he gave it to the priest. They hung it up in the church, said prayers and went away, and that very night it disappeared.'

'Was the church locked?'

'Yes, indeed it was. It simply vanished as though it had never been. So they went to look by the spring, and there it was in the sedge, just where the boy had found it. So they brought it back to the church and said prayers over it again, but they were troubled in spirit.'

'I suppose this was quite a short time ago, since you remember it so well?'

'Oh, goodness me, no, it was in olden days. I'm telling you the story as it was handed down to us.'

'You tell it as if you had been there yourself.'

'Sometimes I feel as if I had been. I expect that's because I've looked at the icon so much. I've got used to it, and I feel as if I'd always known it. And I picture to myself how it was found, and the little boy, and how frightened everyone was when it vanished from the church for the third time and was found again in the sedge near the little spring.'

'It actually vanished three times?'

'Yes, it did.'

'So what did they do?'

'They sent a procession to fetch it. The whole parish, and all the neighbouring villages, with banners and all the other icons carried on linen cloths, and hymns, and all the bells pealing.'

'And did it stay in the church after that?'

'Yes, it ceased to wander – it stayed until the church was closed for good. People worshipped it and said their most heartfelt prayers to it. Well they might, for it wasn't just holy, it was mercilessly beautiful too. There's never been such beauty.'

I was struck by Pasha's phrase 'mercilessly beautiful': she had meant, no doubt, to refer to the 'Merciful Virgin', but had got confused in her expressions. Yet, I reflected, all beauty

is power – an absolute, indestructible power, which either throws you at its feet or lifts you up to itself. Beauty is that which we cannot resist, and therefore it is indeed merciless.

'Yes, such a beauty as never was on earth. They worshipped her as though she had been a living queen. When they got within ten paces they would fall on their knees, and if their sins were very great they crawled towards her, and didn't dare to lift their eyes. And now you see . . .' she smiled happily, 'now she has taken up her home with me, a poor simple peasant woman.'

'How did it happen?'

'When they closed the church, a woman rescued the icon and hid it in her house. Later on she went away to live in town, and she called me to her at night-time and gave me the icon and said: "Here, Praskovya, I give it into your keeping. I mustn't take it with me, because this village is where it appeared and this is where it should remain".'

'What made her choose you to give it to?'

Pasha smiled again, a bashful but happy smile.

'It must have been decreed that I should have it. But why I should receive such a blessing nobody knows, neither I nor anyone else.'

By this time we had reached Pasha's house. It was clean and tidy, with curtains on the windows and coloured mats on the smooth floorboards. I expected that as soon as we stood inside I should see a large icon, such as one finds in churches, clothed in shining metal overlays and hanging in the 'front corner' – for a wonder-working icon would surely have been decorated with metal, and Aunt Pasha would surely have kept it shining bright. But all we saw in the hut was an ordinary shelf with three ordinary-sized icons on it. Pasha climbed up on the bench, crossed herself, took down the icon which stood on the left of the shelf, and placed it carefully on the table.

It was a Kazan Virgin, covered with metal except for the faces of the Virgin and child. The stout, heavy panel had warped with time; the cleats had disappeared, and their grooves were as black as the board itself. Under the metal there would no doubt be a double indentation at the edges. In short, it was a seventeenth-century Virgin of Kazan; and yet there was something quite unusual about it. I do not think it was because Aunt Pasha's story had put us in an imaginative mood: no, it was simply that this Virgin by an unknown artist was incredibly, extraordinarily beautiful. Not with the flesh-and-blood beauty of a real woman, but a different beauty that is hard even to describe . . . I remember an episode I read recently in a novel about old Novgorod. A merchant commissions an icon of St Paraskeva, and the painter, to please him, takes the merchant's young wife Domasha as a model. The icon is brought and shown to the merchant, and – I cannot improve on the author's words:

Oleksa gazed at it, and gradually became deaf to all around him. St Paraskeva was looking at him with Domasha's eyes, full of suffering, compassion and wisdom. The face was somehow different and more elongated; the nose too was longer, after the Byzantine style, and the mouth narrower . . . The artist had made her look older; yet the face was not old, but as though everything fleshly and ephemeral had been purged from it, leaving only the beauty of a mother's face that endures till old age, till the hour of death.

The young writer whose words I have quoted speaks of age, but looking at Pasha's icon one had no thought of guessing the age of the woman it depicted. Neither age, nor time, nor any sort of vanity was here – but a different kind of value, a different beauty, perhaps the spirit of beauty itself, embodied in a painting on a clumsy, coal-black board.

The absolute impossibility of our ever obtaining this matchless icon made it seem even more beautiful. All we could do

was to tell Aunt Pasha that she must under no circumstances wash it with water.

'Of course not – I shouldn't dream of it,' she reassured us. 'I only use the least bit of oil every once in a while, on very great feasts.'

There were still a few large pearls on the metal overlay, but they were dull and lifeless. It is well know that pearls lose their lustre when they are not in contact with the human body.

*

All failures are disappointing, but we were not so cast down as might have been expected by our visit to Aunt Pasha, or our fruitless efforts with Feofan (St George the Victorious) or Pelageya (the head of the Saviour). The fact is that we were bent on a different quest, and these visits were incidental.

The book that I have mentioned several times declares in black and white – without exclamation marks or other signs of emphasis – that:

There are two altars in the church, one dedicated to the Protection of the Blessed Virgin and the other, in a side-chapel, to the Holy Martyrs Florus and Laurus. The chapel possesses an iconostasis from the disused wooden church: it is an ancient one, with icons in Byzantine style.

'We'll be there any moment,' we thought to ourselves, 'and the church will be intact.' It might be closed, of course, but the building would still be there in the middle of the village; it may have been turned into a storehouse. If it's a club, or a shop, or a bakery, or a garage, or a milk distribution point, or a joinery, then things are not so good. It often happens that you see a nice-looking church from a distance, perched on top of a hill like a toy. You make a detour to have a look at it, and you find it is only an empty shell. There are great holes in the walls, and a hole where the door used to be, and the building

is supported by four stumpy columns at the corners. You step in under the arches and see the remnants of painting on the walls and hear the wind whistling in the belfry windows. The church is on a high riverbank, and you can see twelve miles in all directions. In the distance other churches and bell-towers stand out white against the summer sky, and the same wind whistles through them.

If the church has become a cinema, a shop, a bakery, a garage or a dairy, then of course nothing remains of its internal appearance: the painted walls are plastered over and white-washed.

In one church, which had been turned into a handicrafts school, all the furniture, icons, etc. were piled into the sacristy, which was then walled off from the rest of the building; the wall was revetted with boards which were covered with yellow wallpaper. We got the school authorities so interested in seeing the treasures that might be behind the wall that they were almost ready to pull it down, but in the end we did not press them to and so we never found out what was buried there. But that was an exceptional case. Usually if it's a shop or garage there is nothing left of the church furniture, let alone old icons.

A collective-farm storehouse is a different matter. If the village church we were now on the way to, with its Byzantine-style iconostasis, had been turned into a storehouse, we should begin by finding the storekeeper and getting him to open up for us. In the main part of the building there would be nothing of interest except perhaps a crucifix hanging askew under the dome, and even that would probably have been brought down with a lasso and disappeared without trace. But then we would go into the Florus and Laurus chapel, and in the gloom, among the empty barrels and crates, we should see the blackened old iconostasis from the wooden church, and the picture of Florus

and Laurus with the herd of horses. The horses would all be black with linseed oil, but once the restorer got to work they would be white, black and red, against a golden Byzantine background.

But wait a moment, we thought to ourselves. A storehouse is better than a shop, certainly, but most churches have been demolished altogether for the sake of the bricks. Anyway, what would we do if we did find an intact Byzantine iconostasis? The first thing, no doubt, would be to rush off a telegram to the Tretyakov Gallery. What exactly did we mean by 'antique' and 'Byzantine' in this case, and how did the icons get here? They must date from the twelfth or thirteenth century and come from Suzdal, which was not far off. No doubt they belonged to some church there which was rebuilt at a later period, after the Suzdal school of Russian icon-painters had come into existence. The Suzdal people wanted a fresh, bright iconostasis in their new church instead of the old dark one, which was somehow foreign to Russian taste; so the peasants of the village we were bound for would have bought the old iconostasis, or simply appropriated it, and used it for their own wooden church. . . . Then, later on, when that church was replaced by a stone one, they would have transferred the iconostasis to a side-chapel so as not to spoil the new building by its dark appearance; and in that chapel we hoped to find it. We would duly send a telegram to the Tretyakov Gallery – a whole iconostasis in the Byzantine style could not be left in the hands of private collectors! All the same, we might keep Florus and Laurus and the horses as a reward for our enthusiasm, detective zeal and pertinacity. Just Florus and Laurus – the Tretyakov people were welcome to the rest. After all, you couldn't expect a whole twelfth-century iconostasis . . . Why, there would be the Festivals, the Deesis tier and all sorts of other things – perhaps even a St George or a St Michael.

Driving round a bend, we suddenly came on the village of our quest. The church dome, with its cross knocked sideways, rose above the houses and trees. At all events it had not been broken up for scrap! Too impatient to look for a storekeeper, we stopped and questioned the first village woman we saw: she was coming away from the well, with two buckets full of water.

'No, I'm afraid there's nothing left inside. When the church was closed they took all the icons away.'

'Where to, do you remember? Did they mention a museum or anything?'

'They turned them into horse-troughs.' She began to whisper mysteriously. 'There might be times when you'd be feeding a horse and you'd bend over the trough, and get the fright of your life to see the face of Christ or the Virgin looking up at you. Such stern faces and big eyes – it made your heart stop beating.'

So they had closed the church and dismantled the iconostasis – perhaps it was the right thing to do, since there was no room for icons in a granary, and having done so they might have stored them somewhere or even burned them, but why had they chosen to use them for horse-troughs?

*

An extraordinary thing had happened to us in one village. We were told that the church had been pulled down a long time ago, but the icons had been stored away in a barn and were still there. From where we stood we could see a green meadow with lots of little black sheds, two or three dozen of them clustered together or strung out in a row. They had once been used to keep spring-corn in; now they were disused, but the icons were said to be still in one of them.

We spent a long time looking for the man who might have

the key to the precious shed, but we needn't have bothered. When he took us to the shed it had neither a lock nor a door, unlike all the others. The little wooden structures, which had once been stout enough, were overgrown with grass, blackened and mouldering, like something out of The Sleeping Beauty. Even the mice had given them up long ago – there was nothing left to nibble, not even the smell of flour or corn.

It was getting dark. I felt for a moment as though we were a party of divers who had come across the remains of a dwelling at the bottom of the sea; the dark-grey starlings that wheeled past us were like a shoal of frightened fish. The floor of the shed was over an inch deep in gold, white and red particles of dust, gesso and paint that had crumbled from the icons. Little was left of the boards: no doubt they had gradually been taken away for various odd jobs and for the peasants' everyday needs. Such boards as were still lying about had had the paint washed off them, as the roof was full of leaks. One icon of moderate size was lying in a corn-bin, face down. The painting had crumbled at the edges, but the centre was intact: it was a seventeenth-century Nativity. There was also a large icon of which one corner was unharmed, about an eighth of its area. We asked if we might take these pitiful remains away with us. The man with the keys was surprised that we wanted them, and full of regret that the rest had been destroyed by rain.

Determined to see the thing to a finish, we moved on to the cattle-yard. Although none of the paintings could have survived, we might look at the reverse side of the boards and tell from them what the age of the lost works of art had been. But it turned out that not even the troughs were there any more.

*

This, then, was our major disappointment – a climax to the lesser ones, which would not themselves have mattered if we had been able to salvage at least a 'Florus and Laurus' from the dark chapel of the empty church.

The storeroom was open, and I saw the former chapel in which the antique Byzantine icons had hung; the cross-beams were still in position and I could judge how big the icons had been, but this did not console me in the least.

13

Dusk was falling as we set out for home. Driving back through the large, old-fashioned village we felt sufficient energy and determination to try our luck once more. As it turned out, it would have been better if we had not stopped.

We met a farm worker and asked him if there were any old things to be seen. He scratched the back of his head like a stage peasant, tipping his cap down over his eyes.

'I don't know. There's nothing left now. It might be worth asking Uncle Peter.'

'Why do you think he might have something?'

'His mother had to do with looking after the church all her life. Of course it's been pulled down now, same as anywhere else, and a good thing too, but the old girl did take some of the icons home with her. Now she's dead and Uncle Peter is left, it might be worth your while to see what he's got.'

'Tell me, is he a very religious sort of man? Because there are some who won't part with the things for love or money.'

'Don't worry, he drinks like a fish – a real alcoholic. He'd let you take away his own carcase for a rouble or two, never mind a few icons.'

As I stepped from the porch of Uncle Peter's house into the hall, my feet stuck in the wet paint. I stood there awkwardly – I could not go on without spoiling the floor, and I did not want to turn back. Suddenly a youth in a sports shirt appeared behind me and called out: 'Don't worry, jump across, it's all right further in.' Now came, as usual, the embarrassing moment when I had to explain in a dozen or so words what I was there

for and why I was so keen on icons. I managed as well as I could, and the youth – he turned out to be a tractor-driver named Vladislav – did not seem perturbed. He replied: 'Go on, have a look – there are three in the front corner there, and some more out in the kitchen, but those are not so good, they're darker.'

There was nothing worth looking at in the front corner – only three quite modern icons with glittering metal overlay, hanging one above the other in an oaken frame. In the kitchen, however, I found some dark ones without metal overlays standing in no particular order, and examined them one by one, turning their faces towards the window. A Burning Bush of the eighteenth century, a Pantocrator of the late seventeenth. The Virgin of Kazan – I gazed at this one and thought to myself: 'It can't be, it's an optical illusion!' What I held in my hands was the same wonder-working icon that Aunt Pasha had shown us a few hours before. I wondered how this could possibly have come about, and finally hit on a reasonable explanation.

Both the villages in question were ten or twelve miles distant from Suzdal, which was a centre of iconography in the seventeenth century. Might not a single craftsman have painted two identical icons of the Virgin of Kazan, and might they not have found their way into the parish churches of two neighbouring villages? Later, as we see, their fates diverged. One rose to the dignity of a wonder-working icon and was preserved by the God-fearing Aunt Pasha, while the other was lying about in a kitchen belonging to the drunken Uncle Peter, whom we now urgently desired to meet.

Here in my hands was that very same 'merciless beauty', and instead of our quest being a fiasco it had turned, by the merest of chances, into a dead certainty. In a minute we should meet Uncle Peter, who would 'let us take away his own carcase for a rouble or two' – and besides, this was not a wonder-

working icon, not one that its owner would cling to with the obstinacy of a fanatic. The miraculous one was out of reach, but the one here was absolutely identical in all other respects – just as beautiful, just as splendid, even though it was a common maiden and not the princess.

I asked Vladislav where his father had gone to, and he replied: 'He's gone drinking with a friend in the next village.'

'Will he be back soon?'

'Maybe another two days. He and his friend usually take that long. Wait, I'll ask Mother – she's cleaning up the garden.'

He was away for an agonisingly long time, during which an unpleasant feeling crept over me that for some reason the story would end with my having to put the icon back on its shelf again.

A small, wizened, bustling female who looked about seventy, though she was of course younger, with little hair and grimy hands, appeared on the threshold. Even before she did so I heard her angry voice:

'Well, what does he want?'

'I don't know – he's looking at the icons.'

'I'll teach him to look at icons! Does he think this is a bazaar? Just you wait, I'll teach him!'

After these words I expected the old woman – her name was Aunt Dunya, short for Avdotya – to appear brandishing a broom or a poker, but her hands, though covered with earth, were empty. She was not tall, but as she stood on the threshold she seemed to glare down at me like a bird of prey. In reply to my timid, ingratiating words of greeting she snapped: 'Well, what is it? What do you want here? Be off with you!'

'Listen, Aunt Dunya, please sit down and don't get so excited. Listen to me and I'll explain what it's all about.'

'It's no use telling me – I'm a simple woman, I don't understand things, you're wasting your breath.' However, she sat

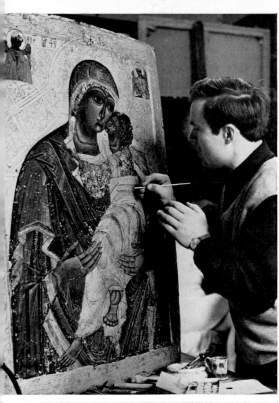

'The Virgin of Compassion',
15th century, found in
Volhynia

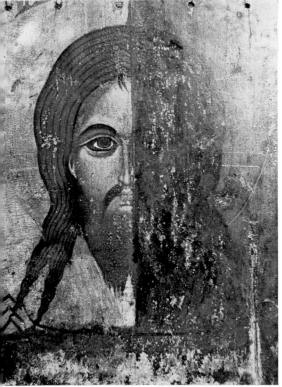

An icon of a Holy Image of
the Saviour 'Not Made with
Hands', found in Novoye,
Yaroslavl Region (half of the
icon has been restored)

down on the bench; her hands with the earth drying on them rested on her knees, palms upward. For the next hour and a half, during which I exhausted all my eloquence and powers of conviction, ranging from sincere arguments to demagogic ones that should have been no less effective, Aunt Dunya kept on repeating: 'I've told you already, I don't understand things like that. But I won't change my mind about the icons. The idea of my letting you take one out of the house – how do I know who'd get hold of it? You'd only make fun of it, anyway, you and your friends.'

'But we wouldn't, Aunt Dunya – the very opposite! Everyone would admire it as a beautiful picture, a great work of Russian art!'

'There you are – who says icons are there to be admired? Prayers are what they're for – you pray to them and you keep a light burning in front of them. Is an icon some sort of naked girl, that you want to admire it?'

'You don't understand what I mean, Aunt Dunya.'

'I've told you already, I don't understand things, so you needn't waste your time asking. I won't change my mind about the icon. How could I deliver it into the hands of strangers? If I did, Our Lady would appear to me at night and say: "Avdotya, how could you do such a thing as to give me away to the first person who asked?" What could I say to her then, what could I reply to our Blessed Mother?'

I felt desperate – it was getting dark, we ought to be on our way, but as I looked at the beautiful image of the Virgin I felt a fresh access of strength. Meanwhile Aunt Dunya was exclaiming angrily: 'Money! So you think icons are for sale! Why, she would come to me at night and say: "Well, you miserable Judas, how many pieces of silver did you get for me?" '

'Listen, Aunt Dunya, how can you say icons are not for sale?

People used to buy them at the bazaar in the old days, or from pedlars, and they would even haggle about the price, too.'

'I won't change my mind.'

'I promise you I'd let everyone know where I got it from. I'd say it came from Avdotya Ivanovna's collection.'

'I won't change my mind.'

'There'd be a label underneath, or a brass plate, saying "Avdotya Ivanovna of the village of . . .".'

'Get behind me, Satan! Heavens above, you've made my head ache! Go to the man next door, he's the village librarian. He's got a better icon that this one, even, it used to be his mother's. It's no use to him, he'll only throw it away. Off you go there and ask him.'

I withdrew, discomfited, to what I thought might be an advantageous position. I had thought of a plan: I would make friends with the librarian, and get him to work on Uncle Peter so that when he was sober he would give him the icon. Then, a few days later, I would come along and get it from the librarian's house . . . No, that wouldn't do. If Uncle Peter removed the icon beforehand, his wife would notice and make him tell her where it was, and fetch it back again. I must simply get the librarian to prepare Uncle Peter's mind, so to speak, in order that the icon could be removed when I was actually present. Then I would hop into the car with it and drive off, waving a hand to Aunt Dunya if she should happen to be standing on the doorstep.

The operation should be simple enough, as the two houses were side by side. The librarian's was more untidy-looking, naturally enough, as he had the village club to look after, while his wife, it turned out, was a teacher. Introducing myself to him, I laid stress on the fact that I was a writer – if by any chance he had ever heard my name, it would make it easier to broach my rather tricky proposal.

He was a man in his thirties, who greeted me in a lively fashion and kept apologising for the fact that his wife was out, otherwise they would have liked to entertain me, but another time I really must . . .

'Yes, another time, that's an excellent idea. As a matter of fact I was thinking of coming back quite soon, in three or four days perhaps.'

'Splendid, splendid. So you're thinking of making a private collection of peasant utensils, old Russian painting and all the rest of it? We'll give you all the help we can. I'll talk to the people here and find out which of them have got any old stuff. I'll conduct negotiations with Uncle Peter – nothing easier. Though it's a pity we didn't try him before you tackled his wife. Never mind, we'll fix it up. He came round two days ago wanting to sober up here. But could you give me some idea, just in case I need to know, about how you tell an old icon from a modern one?'

At that moment it occurred to me that my friend was playing a double game. He did not believe, in all probability, that I intended to form a private collection; he thought I meant to get hold of all the icons and other antiques in the village and sell them to a museum, for instance the one at Suzdal. In that case, why should he let a stranger have them instead of doing the same thing himself? I gave him a truthful account of the signs by which an old icon is distinguished from a modern one. He listened with half-open mouth, asking questions and drinking in what I told him about cleats, bevelled edges, gesso, linseed-oil and so forth. Then I said: 'Aunt Dunya told me you have an interesting icon of your own. Let's look at it and I'll tell you its date.'

'I'm just wondering where it's got to. My wife must have hidden it away somewhere. The frame's over there.' He pointed to the wall, where there hung in a golden icon-frame a

poster entitled Happy Motherhood, depicting a rosy-cheeked woman with a podgy infant in her lap. As far as subject-matter was concerned, it corresponded to the icon-theme of The Child Playing – but it was a commonplace modern print, and the golden frame had been decorated, of all things, with carvings of flowers, vine-tendrils and so on.

'Where can it have got to?' mumbled my host, peering under the wardrobe, under the bed, under a chest, behind the stove. 'That's its frame all right, but we used it for a poster. My wife must have hidden it away somewhere. Next time you come we'll have it out for sure. Well, when will you be in these parts again, maybe next week?'

*

The smooth country roads, bordered with clover, came speeding towards the car and were swallowed up, mile after mile. I shot up hills and sped round corners, pursued by the cackling of terrified hens that scattered to either side of the village streets. I was on my way back to see the librarian, who by now had doubtless arranged everything with Uncle Peter, so that I might return home the possessor of the longed-for icon.

I felt thirsty, and as I was passing through a village I stopped in front of a building with a brick lower storey and the sign 'Buffet'. Here they offered me some stale lemonade, but I refused it and was given instead a glass of clear water from the well, which I drank with relish.

Suddenly the radio blared forth. I looked at the waitress enquiringly.

'Didn't you know? For the past two hours a Soviet citizen, German Titov, has been flying in space.'

From then on I stopped in every village and asked the first person I met: 'How's he doing?' And that person, without

asking whom I was talking about, would reply: 'He's in orbit. He's completed the full programme for the fourth circuit.'

How strange! I thought to myself as I struck out again across the fields. German Titov – a name that nobody had heard of yesterday and that everybody knows today, from Uncle Peter and the village librarian to the inhabitants of Kamchatka and the whole world – this German Titov is my own contemporary. He's probably a few years younger than I, but we belong to the same generation, the same period, the same country. And here we are, two contemporaries, engaged on fantastically different errands: one of us in space, carrying out the programme for his fifth circuit of the earth, and the other driving through the countryside on his way to ask an old woman to give him a blackened wooden icon.

But just a moment, let us not consider too hastily. Let us leave out of account the collector's passion, his zeal for a private hobby, since otherwise we should have to compare Titov to the angler who sits for hours in the hope of catching a tiny fish. Let us simply recall that this icon is a painting, and an ancient one at that – in short, a work of art. Looking at it this way, the comparison is perhaps not so absurd and humiliating from my point of view. On the one hand science, on the other art. On the one hand cold, accurate calculation, mathematics, electronics, cybernetics; on the other beauty, intuition, the soul and its blossoming. Art is the blossoming of the human soul – or rather it blossoms in love, which in the fullness of time produces art like a ripe fruit.

Science knows how to melt a ton of steel in a single second; art can make a man a little better than he was before. Science cannot soften the human heart: it will not make a man readier to share his last crust, to answer the smile in another's eyes or to press a fellow-creature's hand tenderly. Science is for the brain, the intellect, material welfare and physical convenience;

art is for the heart and soul. Science makes a man stronger in body, art in mind. Moreover, above all, art can make a man somewhat better and this he badly needs, especially in an age in which science and technology are making irresistible progress.

Reasoning thus in my own defence, I drew closer to the village of Uncle Peter, Aunt Dunya and the librarian. The librarian had heard me approaching or seen the car through the window: he came to his doorstep to meet me.

'How is he?' I said after we had greeted each other.

'He's asleep.'

'I don't mean Uncle Peter, I mean the space-man.'

'So do I. He's asleep. Asleep in orbit, just think of that. We really ought to celebrate it. My wife's at home today, we've got some pickled mushrooms.'

'It's certainly worth a celebration.'

'Then let's go to Gavrilov-Posad – it's the local centre, I expect you know it, a little old town. We'll be there in no time, it's only a dozen miles.'

'Can't we get anything to drink in the village? I passed a store that was open.'

'The store's there, but they haven't got what we want. We'll be lucky if we find it at Gavrilov-Posad.'

It was indeed quite common in those days to find small towns and villages in which there was neither wine nor vodka to be had. Not that there wasn't enough of it up and down the country, but some local authorities would order storekeepers not to sell vodka or at any rate to keep it in short supply. We were the victims of one of these ordinances, and therefore made off to Gavrilov-Posad. It was not a long drive, but a very dull one. When we got there it was the noonday break, and we had to wait for the stores to open. Then it turned out that none of them had any vodka, but a place on the outskirts was rumoured to have a stock of red wine. The townsfolk made off there in a

body, and we followed them. The shop in question kept hours of its own, and was closed for lunch now that everywhere else was open. We waited for a good hour, by which time a large crowd had collected: its two topics of conversation were what Titov was doing and what the shop would sell when it opened. At last the narrow door was unlocked and the crowd poured into the small, stuffy interior. We could hear people arguing inside:

'It's red Moldavian.'

'How strong is that?'

'Sixteen degrees.'

'Call that wine? It's more like lemonade.'

'I'll take ten bottles.'

It was the best part of another hour before my friend could get to the counter; I handed money across to him, and he passed back to me over the customers' heads half-litre bottles with cheap labels, twelve in all, containing a villainous reddish liquor. I imagined the combination of pickled mushrooms with this sickly stuff, and felt still more hot and nauseated than I already was from the atmosphere of the shop. All I could do was to console myself with the ancient truth that there is no art without sacrifice.

When we got back to my friend's house the pickled mushrooms and boiled potatoes were on the table. They would have been just the thing with a decent vodka, but as for this imitation port wine! I drew a deep sigh and began pouring it into the thick glasses.

My affairs, it appeared, had made no progress whatever during the past week. Uncle Peter was still treating his hangover, and there had been no chance to talk to him. The librarian ran off to invite him to share our twelve bottles, but alas, he had been drinking steadily since morning and was now asleep; according to my friend, it was hopeless to try to wake him.

'Never mind,' the librarian continued. 'We'll go and see Aunt Dunya and talk her round, but first of all I'll show you all sorts of interesting things my father left me – he was fond of collecting household utensils, my father was.'

We walked along a narrow path between the orchard and kitchen-garden. 'Anything you see here,' said the librarian, growing more and more expansive, 'anything you like the look of, take it – it's yours.' At the end of the orchard, among some cherry-trees, we came to a small shed, piled full of all kinds of peasant utensils. There were round weights, an old-fashioned balance made half of wood, an excellent oaken flail, a large sieve of the kind used to winnow wheat or rye in the summer breeze, a strong bast basket for sowing, a quantity of sickles, parts of a hand-loom and many other odds and ends, including an ingenious contrivance by which the peasant at market could tell whether the oats in the middle of a sack were damp or not. This consisted of a long wooden needle with a deep hole in it: you pushed the needle into the sack, and when you drew it out there were grains left in the hole, the condition of which you could test by biting them.

In view of my host's genial promise, I put to one side such of these articles as I thought I should like to have. He watched me closely as I did so, and once again I felt suspicious: was this merely a trick of his to find out which of the things were junk and which would be of interest to a museum?

'Well, could you give me a hand to take all this to the car? The flail, the sieve, this basket, and the balance, and this contraption from the hand-loom?'

'You know, old chap, I don't think I'll let you take these things today after all.'

'But you just said I could have them.'

'No, I can't part with them today. There's a compelling reason. You can take these weights, though, if you like.'

'What do you mean, a compelling reason?'

'Because I want you to come and visit us again.'

'But I will anyway.'

'No, you won't: if you take everything today, I'm sure you'll never come back.'

I looked at him to see if he was at all ashamed of his barefaced stratagem, but he wasn't. Silently, feeling cross with each other, we walked to the house, had some more wine and then went over to Aunt Dunya's. By now I felt no confidence in the enterprise; I'd be lucky if my host hadn't warned her not to give up the icon on any account. Aunt Dunya, up in arms as before, greeted me from the threshold.

'Well, what have you come back for? I've told you once, isn't that enough?'

'Aunt Dunya, do please listen, I'll tell you the whole story exactly as it is.'

I talked and talked, but I had ceased to carry conviction even to myself. Once or twice I thought she might suddenly say: 'All right, I'm sick of your talk, take it away and never let me see you again.' But she merely sighed like someone awaking from sleep and repeated: 'I'll not change my mind.'

'What if I bring you a fine new icon all the way from Moscow?'

'My mind's made up, I won't change it.'

'Think of this, Aunt Dunya. We don't live for ever. What's going to become of the icon after you're gone? They'll chuck it into an attic or burn it, and Our Lady will come to you in the next world and say: "Avdotya, how could you have abandoned me to a fate like that? While you were still alive, you should have seen that I was left in good hands. Don't you remember, there was someone who wanted to look after me?" '

'Begone, you Satan, don't tempt me into sin. I've given you my answer, and I won't change.'

After the onslaught on Aunt Dunya, the rest of our feast was decidedly a failure. The potatoes and mushrooms tasted horrible after the sweet wine, and vice versa. The librarian told me a long tale about some idea of his moving to town: I could make little sense of it, but apparently he had been offered a job in Gavrilov-Posad, in a factory recreation hall. They would give him a room there, and life would be easier, but he would hate to leave his father's house and grounds – the garden and orchard, the open air, the grass and the dew and the summer rain – and go and live in a room measuring eighteen square yards, among a lot of factory workers whom he'd never seen before.

My attention kept being distracted by some trifle, something about the room we were sitting in that I must have seen but not taken in properly, and which was now preventing me from listening fully to what my host was saying and giving him sensible, practical advice. What on earth could it be? The dresser, the screen, the carved gilded frame and the poster of Happy Motherhood; yes, of course, the frame belonged to the icon, but he still hadn't produced that: he knew where it was, he told me, but he wanted to show it to someone else first . . . I remembered that Korobochka in Gogol's *Dead Souls*, before making a bargain with Chichikov, had gone off to the nearest town to find out what the going rate might be. All right, so my host had hidden the icon, he didn't want me to see it. He was a decent enough fellow in his way, talkative and sociable, but he wasn't going to let me see the icon. There was its gilded frame, and there was Happy Motherhood fastened to it with drawing-pins . . . Fastened to what? One of the pins was an inch from the corner, the other an inch and a half. What were they stuck into? Aha, my librarian friend – so you couldn't find the icon! You looked under the bed and the chest, and behind the stove. Well then, just watch – I'll show you where it is!

Before he could say a word I snatched the icon down from the wall, laid it on the table and whipped off the poster that was covering it. There, underneath Happy Motherhood, was the Resurrection and the twelve other Festivals. It was a late painting of no special interest, except that instead of the usual small panels the surface was divided up by the device of a large tree with oval and rectangular spaces between its branches, a different picture in each. This was an original idea, and it might have been worth adding the icon to one's collection; but I was too vexed with its owner to think of doing so. I re-affixed the stupid poster and hung it back in its place. My host looked at me in perplexity, but I said nothing and went on sipping the awful wine. Finally he could bear it no longer and said with a tremor in his voice: 'You reckon it's no good, then?'

'Of course it is. It's good for praying to. That's what an icon's for: you hang it up in the front corner and say your prayers to it.'

'No, I mean as an antique, a museum piece.'

'Oh, it's no good for that.'

'Well, well, fancy – I thought it was antique.'

*

Later, several years later, I heard by chance that he had not taken my word for it but had shown the icon to the Suzdal museum, where they put an end to his doubts by assuring him that it was not valuable.

I drove home in the darkness, taking with me only the flail, of which he made me a parting present, having carved on it his initials and the date.

'Why did you want to date it like that? It's at least seventy years old, but now it looks as if it was made this year.'

'I never thought of that. Oh, well, it doesn't matter; you can explain how it came about.'

One flail is not much of a dividend for two exhausting trips – though of course one may add to it the lines that you have just been reading.

14

I WAS on the way back to Moscow from Rostov near Yaroslavl, and had just driven through a village that straggled along the highway, when I suddenly felt a kind of mental uneasiness.

When one is walking along a busy city thoroughfare, wrapped in one's own thoughts and not noticing the passers-by or looking at their faces, it sometimes happens that one stops, wakes up as it were, and turns round to look for someone half-consciously glimpsed in the crowd. It may have been a pretty woman's face, or an acquaintance walking the other way who may have nodded to you. But you can hardly run back and scan everyone's face, so you walk on, doing your best to remember or imagine what it was that caught your eye.

I felt this kind of uneasiness on the road from Rostov to Moscow, just as I had got to the end of the long, straggling village. I turned the car round and drove slowly back, looking to either side. There was nothing special to be seen: only the usual wooden houses with fences in front of them, old brooms leaning against the doors, a well here and there, hens and geese pecking about in the scanty grass. Suddenly – I nearly passed it once more – I saw a patch of white beyond the dark foliage of the trees, and realised that it was a tiny church. It stood between two huts, but slightly back from them, and the trees hid it almost completely.

Having thus checked that my subconscious visual memory was in good working order, I might well have driven on without further ado. For, while it was still possible to come across

an old hermit-woman living in the ruins of an out-of-the-way monastery and guarding an ancient icon, or to find two or three old icons in the graveyard church at a remote village like Cherkutino, it was hardly conceivable that anything worth a collector's attention was still to be found on the main road from Yaroslavl to Moscow. How many people travelling for pleasure, how many painters and art historians must have driven back and forth along this road, scanning every detail of it with attentive and covetous looks! All these kinds of people were potential if not actual collectors, and had their wits well about them, and if they saw a church thirty yards from the road they would want to take a look at it, outside and in, and after that – well, in short, it was nonsensical to expect to make a new discovery thirty yards away from the main Moscow-Yaroslavl highway.

However, the church was unlocked, and I decided to look inside. As soon as I opened the door I came upon a pile of oats, a good three feet deep. To get further inside, one had to walk over it. I did so, of course, and later on – much later – I spent a lot of time shaking oats out of my shoes and trouser turn-ups. The storekeeper, a woman, advanced towards me from the other end of the pile of oats.

'It's almost like walking on water!' I said facetiously. But the woman was not amused: she greeted me with a stern, unwelcoming face, being in a hurry to get home to her dinner. I was pleased enough at this, as I had noticed, right up under the dome, a large, blackened icon boarding up a window. The church was so small that I could have climbed up and fetched it down with the help of an ordinary ladder.

As the woman led me out again I kept my eyes on the black board, trying by intuition or second sight to guess the subject. I had the impression that it was a St Nicholas of Zaraisk with scenes from his life. The storewoman dismissed me and went off

to her midday meal, and all I could do was to wait until she chose to come back: one was constantly waiting for other people's breakfasts, lunches and dinners! I walked round the church and admired the exterior – it was a rare gem of seventeenth-century construction. What most caught my eye, however, was not the flame-like shape of the dome, but the fact that a second window was boarded up by an icon, this time with the painting facing outside. The window was fairly deeply recessed, but the rains had washed the black drying-oil off the surface of the icon, and I could see that it was an Old Testament Trinity. It was surprising that the whole thing had not been washed away, down to the gesso or the bare board.

Two hours passed, but there was no sign of the storewoman. I grew impatient and asked the way to her house; when I got there, I found she had eaten some time ago and was now doing her housework and feeding the hens. She was surprised that I had not gone away; however, the meal had improved her temper slightly, and she deigned to talk.

'Well, what is it you want?'

'I'd like to see the icon that's nailed over the top window.'

'Well, you've seen it.'

'I mean, to have a close look at it.'

'D'you expect me to climb up and get it for you? You need a ladder, and I haven't got one. Go and find one if you like, but don't waste any time, I've got to go to the next village and see to a storeroom there.'

'Is that a church too?'

'No, it's a shed.'

'Tell me who's got a ladder here, and I'll go and ask them.'

'Find out for yourself.'

I tried several houses near the church, so as not to have to carry a ladder all through the village, and was able to borrow a long one, not too heavy, from a peasant woman: she came

along to the church, evidently curious to see what sort of an icon could still be there after all these years.

I clambered to the top and found that the icon, like the church, belonged to the seventeenth century, that it was indeed a St Nicholas of Zaraisk with scenes from his life, and that it was in an appalling state. I gave a tug to see if it was firmly fastened; the storewoman saw me and shouted: 'Don't do that! You mustn't unfasten it.'

'Why not?' I asked, after coming down the ladder and wiping the dust off my hands.

'Because if you do, the rain and snow and damp'll get in. That window faces north, I can't have it unboarded on any account.'

'But surely it could be boarded up with ordinary planks?'

'Another job for me, I suppose!'

'I'll pay for the work – you could get your husband or some men to do it.'

'I've got other things to do than run round the village hiring labour. Get someone to do it yourself if you like, but hurry up, I've got to get to my other storeroom.'

Conversation with her was difficult, but at least we had come to an understanding. In a quarter of an hour I had got hold of some farm labourers with axes and planks, and in another five minutes the icon had been taken down and laid on the grass outside the church, its painted surface turned to the summer sky.

Its wretched condition was now even more obvious: it could not be carried to the car, let alone to Moscow. The entire surface, to the last square inch, was peeling off in the worst possible way, that is to say in tiny flakes, each one of which was attached by its centre but curling up at all four corners. There were myriads of these flakes, so that the whole icon looked whitish, as though sprinkled with lime. There could be no

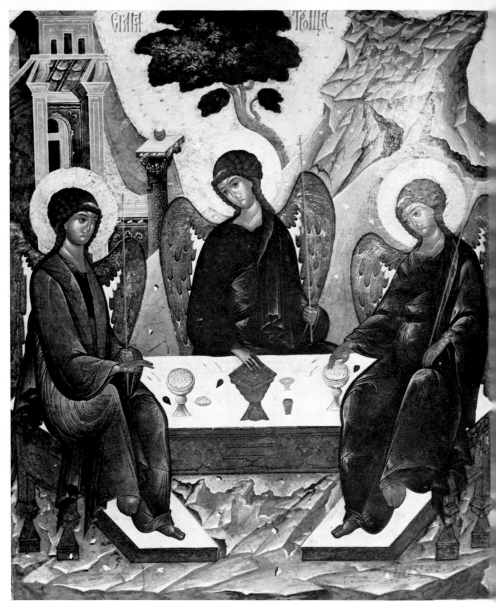

'Old Testament Trinity' painted by Nazary Istomin in 1627

question of rubbing a duster over it; if I had passed my hand over the surface or knocked one end of the board against the ground, the flakes would have scattered in all directions.

The only alternatives were to leave the icon leaning against the church wall, or try to salvage it, which I did as follows. I bought a dozen eggs, separated the whites and threw them away, and diluted the yolks in a large amount of water. The sticky yellowish fluid had then to be applied to each flake in turn, in fact to the whole icon. When the flakes were softened I pressed them down cautiously with a teaspoon so that they adhered once again to their proper place on the board.

This part of the process took several hours. The village children collected around, but they got tired of watching the slow, monotonous work and soon ran away. Some old women came up and, after watching for some time, said cannily: 'Patching it up, are you? Don't you worry, we won't tell anyone.' The men of the village came along too; they sat on an oak log on the grass, smoking quietly and making remarks like: 'Well, what's the thing for, anyway? To the likes of us it's just a bit of firewood.'

'Of course,' I retorted, 'you can use anything you like for firewood, say a table or cupboard or a fine wardrobe, but what's the sense of that when you've got ordinary logs? This is going to be a beautiful icon – it's beautiful already, only you can't see it yet.'

'A cupboard or a wardrobe – that's different, it's some use. You can keep dishes or hang clothes in it. You can use a chair to sit on. But an icon is just an icon and nothing more. It may be as beautiful as you like, but it's no use. Of course people prayed to them once, but they don't any more. So the useful part of it has gone, and it's only something to look at – unless you chop it up for firewood.'

'Of course we're all educated nowadays, you people cer-

tainly are, but perhaps you don't know that in old times there were people who argued just like you: if a thing was useful they would call it beautiful, but if it was just beautiful it didn't count.'

'Well, that shows there were some people with good sense even then.'

'They weren't sensible, they were stupid – and, what's worse, they were wretched people who didn't know what they were missing. Anyway, you folk are not as bad as you're trying to make out. Look at those fences you have, with lilac growing in them and the kind of flowers that look like golden globes. What did you plant them for? They're not potatoes and carrots, you can't eat them. So what's the idea of planting lilac?'

'To look nice.'

'Well, there you are then.' The men burst out laughing.

As I drove away, I kept remembering that I had done nothing about the Old Testament Trinity. But the business of persuading the storewoman again (she had gone off to the other village by this time) and getting some more men to come and board up the other window – all this seemed too much trouble at the time, and I felt a kind of embarrassment as well. Today, with hindsight, I know that I should have spent the night there. But I kept making excuses to myself: it's been up there for thirty years, it can stay a little longer. I'll go back there one of these days and get it down.

*

I did not in fact go back for nearly three years. Every now and then, however, I would think of the little church with its flame-like dome and the Trinity icon looking out from its deep recess. I could feel, almost as a physical sensation, how it must be getting damp in autumn and early spring and drying up in the hot summer breeze; I could feel the gesso cracking, the

paint flaking, whole sections of the picture falling away and revealing the bare board.

When I next had occasion to go to Yaroslavl, I was preoccupied with other matters and forgot that I should be passing through the village with the patch of grass on which I had sat and diluted yolks of egg, the garden with the lilacs, the storewoman's house at the Yaroslavl end of the road. It was not till I saw this house that I realised where I was. Recognising it and remembering, I wondered why the church had not caught my eye subconsciously as it had done on the first occasion. I turned back and scanned the village, but my seventeenth-century beauty was nowhere to be seen. I must be mistaken after all. The place where I thought I had bought the eggs must be similar to one in some other village; so must the garden planted with lilac. I was passing a food-shop now, and that certainly wasn't there before: I knew because I remembered having felt hungry on that occasion, and if the shop had been there I would have gone in and bought something. No, the shop certainly wasn't there. But what about the oak log on which I had sat and talked to the farmers? There it was, still lying on the grass – I recognised it because of the way the inside had rotted.

There were two puzzles, then: what had become of the church, and where had the shop sprung from? Alas, the answer was simple: they had turned the church into a shop. They had knocked off its dome and the upper part with the pretty gables, given it a flat roof and turned it into a fine up-to-date shop that only needed a huge plate-glass window to be in the newest fashion.

And what about the Trinity icon that I had seen looking down from its deep embrasure? Ever since I returned to the village, it has been on my conscience. I ought to have built myself a log cabin, stocked up with food and lived beside the

church until the storewoman gave me permission to take the icon down and save it. As long as I live, that lost Trinity will be on my conscience – it was as if I had walked past a place where a man was drowning, and had not stretched forth a helping hand.

15

SOONER or later, I was bound to take a look at our own village church. My faithful Guide spoke of it as follows:

The church at Olepino village, dedicated to the Intercession of the Blessed Virgin, is of great antiquity. In 1860 an old wooden church in the village was pulled down, and before the altar was burnt it was found to contain three *antimensia* [cloths containing relics], the oldest of which was presented to the church during the reign of Vassily Dmitrievich, son of Dmitry of the Don; the second dates from the time of Ivan the Terrible and the third from that of Boris Godunov.

I do not know what the former church looked like, whereabouts it was or what the rest of the village was like at the time when the church was still standing. What kind of trees was it surrounded by, and was it much taller than they? Was it of the pyramid shape? Did it have only one dome? What sort of icons were in it? Did it have a separate wooden bell-tower, and of what shape? Was it identical in design with its predecessors, or were they all different from one another?

It would indeed be interesting to see what one's own village looked like in the time of Vassily Dmitrievich or Boris Godunov; but alas, there were no photographers then. And today, now that we have them, are things much better? Not long ago the church wall was pulled down for the sake of the bricks. You might think that they would have photographed it from all angles beforehand, so as to fix it in our memories and record it for future generations. All I have ever seen is a few amateur snapshots which happen to show the main arch,

or a corner tower, or part of the wall itself; that is all that's left by way of a record.

According to my memory it was like this. The church was in the middle of the village, on a level piece of ground somewhat higher than the rest. It was built of brick, whitewashed and surmounted by three crosses. The brick wall around it enclosed a fairly large area and was decorated with ironwork. There were four arch-shaped gates in the wall, each surmounted by a small dome and an iron cross. At each of the four corners there was a tower, round at the base and octagonal higher up. Outside, the wall was ringed with ancient lime-trees, the most handsome feature of the village. Up to now these have been left alone, and their stately circle marks the place where the wall and church used to be. The paths inside the wall were paved with massive stones and bordered with acacias, which in former times were carefully pruned every year. After that they were left to grow freely, and gradually turned into a jungle. There is nothing left of them now except a few withered branches: the place has been given over to weeds and nettles.

In olden times people were buried within the precincts. I never saw this done, but I remember the gravestones and crosses. The gravestones, incredible as it may seem, were made of white stone or even marble; I think of them nowadays when I see little pyramids of plywood decorated with cheap silver paint. Among the graves there used to be hollyhocks growing.

When we were children, the village was passing through an interesting and important period of its history: to be precise, it fell to our parents' generation to overturn and uproot all the crosses and gravestones. After that they lay about for a long time, and we used to have competitions of strength to see who could stand the tombstones upright. Some were so heavy that all of us children together could not lift them off the earth.

The churchyard with its graves, the hollyhocks and acacias,

the corner towers, the ancient limes and, last but not least, the belfry formed an ideal place for playing hide-and-seek. Once the bells were taken down we had free access to the tower and the church loft, where we found a lot of old, blackened icons, some falling apart into their component boards, and also a quantity of 'wooden dolls'. I believe that if all these things had been collected and arranged they would have done credit to a large museum, not to speak of a private collection. When the old church had been destroyed, people had evidently been loth to jettison the icons and wood-carvings, and they had been piled into the loft. I remember, too, that one of the corner towers had an upper storey full of black icons and painted 'wooden dolls'. And, if an *antimension* from the days of Dmitry Donskoy* could survive until modern times, why might not the same have been true of an icon or a sculpture?

Our elders did not care in the slightest what became of church property, and we urchins used to sail the icons on a pond like boats, manned by the 'wooden dolls': the object was to sink the 'enemy fleet' by hurling stones and fragments of brick at it. What masterpieces of ancient art we destroyed in those days will never be known. Thirty years after, now that I have taken up icon-collecting, I recall those naval battles of ours with horror, but there is no altering the past. One can only hope that when the old church was pulled down and its icons relegated to the loft or the belfry, a few icons, or maybe just one, were spared, and that room was found for them in the new church.

*

A few years ago, returning from Moscow to my native village as I always did in early spring, I found the church closed. Two

* Russian prince (1350–1389) who inflicted a decisive defeat on the Tatars at the battle of Kulikovo (1380).

183

men had already come from the department of education to see what valuables it contained and what could be destroyed on the spot.

This had been decided during the winter, and my mission was confined to trying to save the church building, which was slated for demolition by the First of May on the cogent ground that the bricks were needed for a cowshed. My arguments in defence of the church were naïve and helpless by comparison: it would look ugly, I pointed out, it would spoil the appearance of the village to have a heap of rubble in the middle of it. In the end a compromise was reached: they decided to keep the church as a building, but to pull down the wall. The building was presented to the village soviet; but as they could not decide what to do with it, it was made over to the collective farm, who agreed somewhat reluctantly to accept it as a storehouse provided all the books, icons and other paraphernalia were removed from inside. There was an argument about this between the chairman of the soviet and the farm manager:

'What trouble is it to you to clear the place out? You've got your own labour force, you can empty it in a day and use all the wooden stuff for timber.'

'Why should we mess around with all this junk? No, we'll only take it if it's stripped of everything – just the bare walls.'

Not long afterwards I looked through my window and saw the church doors wide open and a truck standing in front. I hurried over to take a last look at everything which had adorned the interior.

Yakov Balashov, the local scrap-collector, had loaded up the truck with tangled metalware and heavy, leather-bound volumes. A group of women stood in submissive silence on the porch, watching Yakov as he carried out and threw on to the pile a font, a candelabrum, some lamp-chains or the copper overlay from a large icon. The women wanted to go inside

and look around, but the new owner of the church would not let them cross the threshold. That being so, I did not like to go in myself, although Yakov would not have dared to stop me. If I had gone in alone in front of the women it would have added to their humiliation and would also have been a mark of solidarity with those who were despoiling the place. So I preferred to take my stand among the women, on the other side from the village scrap-collector, and thus draw a clear line between those who were not allowed in and those who were gutting the church and removing the books. It was foolish, no doubt, but that was where I felt my proper place to be.

At the same time, books were books, and must be rescued. They were old books and I did not know what they were about, but they were BOOKS and I could not let them be destroyed in this casual fashion in broad daylight. A mile and a half from the village, I caught up with Yakov's truck and signalled him to stop. He climbed out of the cab and looked at me enquiringly.

'About these books. Where are you taking them now, what's to be done with them?'

'They're to be pulped. You see what a pile there is – I can fulfil my whole year's plan at one go.'

'Where's your headquarters, the place where the pulping is done?'

'At Undol.'

'Listen, suppose you give them to me instead?'

'How can I do that? They don't belong to me, there's a price on them. No, I can't.'

'What sort of a price?'

'The official rate for pulping. It's the same over the country: two kopecks a kilogram.'

'I see. Well, there's a good lot here – will you sell them to me

for the same rate? You'll be better off then – you won't have the trouble of carting them, and all the red tape.'

'And what about my norm under the plan?'

'We'll register the amount with the village soviet, it'll all be perfectly above board. And I'll see you get something over and above the plan.'

'I don't know, I'm sure. Do you know how much there is here, anyway? It's a tidy lot, they ought to be weighed.'

'Let's make an estimate. Call it an even sum – a hundred kilograms for two roubles.'

'And you'll pay money for all this rubbish?'

'Looks like it, doesn't it?'

Soon the books were unloaded. Warming to the work, Yakov said: 'What about some of this copper stuff while you're at it? Rummage round a bit if you like.'

I started rummaging; but which of the copper things should I take? There was a Gospel-cover with enamel medallions, but every one of these was smashed; a crown used in the wedding ceremony, but it was twisted and broken. I took a copper jug with a lid, which proved to be seventeenth century, and a small ladle of elegant workmanship. That was about all I could use of Yakov's loot – I could hardly carry home a five-foot candelabrum. I did feel like taking the font, however. After all, I myself had once been immersed in it, and so had all my neighbours, from the oldest to the youngest. But a kind of false shame – I cannot call it anything else – restrained me. What should I, a writer, be doing with a font? Books were a different matter, one could understand that, but a font? Later, I deeply regretted my cowardice, and as time goes on I regret it more and more.

When I got home I opened one of the leather folios at random. I do not read Church Slavonic, but I could make out the inscription printed in black and red, in quaint lettering:

'Printed by the command of our devout and munificent Sovereign, His Highness the Grand Duke and Tsar Aleksey Mikhailovich.'* Another unexpected treasure was a set of parish registers containing the names of all the peasants in the village for the past two hundred years. It told who had been to confession and who had not, and who had been joined with whom in lawful matrimony. On the first page of one of these, for instance, I found an entry dated 1871 recording a marriage, on the estate of the Princes Saltykov, between the peasant's son Aleksey Dmitrievich, aged twenty, and Marfa Petrovna, spinster, aged seventeen. It stated that the respective parents and the local authorities had given their consent, that both parties were of sound mind, that there was no impediment by reason of kinship or spiritual affinity, etc. The bridegroom, 'the peasant Aleksey Dmitrievich Soloukhin of Olepino village has set his hand hereto. As the bride Marfa Petrovna, spinster, a peasant of Olepino village, is ignorant of letters, at her request and on her behalf the peasant Ivan Mitrofanov of the same village has set his hand hereto.'

I sorted out the books and arranged them on my shelves. I had succeeded in salvaging the church library of Olepino village but at all costs I must get a look at the icons before they were carted away to Cherkutino, to be burnt there out of sight of the Olepino villagers.

The chairman of the village soviet allowed me the key to the church for twenty-four hours, on condition that I used it without arousing the curiosity of my neighbours; I might look around the church at leisure and take away anything I chose. So there I was alone in the building, hushed but full of echoes. Loose leaves from books were scattered about the floor, and you could not take a step without crunching glass underfoot. Two large icons were lying on the floor: the silver overlays

* The father of Peter the Great.

187

had been stripped from them, and one had a corner chopped off. I could see at a glance that they both belonged to the seventeenth century; I picked them up, carried them towards the door and leant them against the wall. As I did so I thought to myself: very well, these people are not believers and there is no reason for them to respect the church on that account. Nor, perhaps, do they have any feeling for beauty, or realise that everything here, from the books to the painted ceiling, is the product of human labour. But, even ignoring all that – this is the place where their fathers and grandfathers and all their ancestors were married, not to mention a great many couples who are still living. Does not the place where our parents were married deserve better treatment at our hands? In this place, too, our parents and grandparents and ancestors over the centuries have been laid to rest. Does not the scene of their funeral rites deserve better treatment at our hands? From this, it is only one step to reviling their very graves.

The main iconostasis in our church was no doubt painted in 1859, when the brick building was put up; any icons that were darker or in a different style must belong to an earlier period. On this principle, I selected and placed near the door an Ascent of Elijah with scenes from his life, a St Nicholas, a Protection and an icon of the Virgin of Vladimir.

Only one icon made me hesitate. It was still in position in an iconostasis in the remotest corner of the darkest side-chapel. It was pitch-black, with an overlay of cheap brass plates, and the surface had been decorated with cheap tinsel. I pulled at one corner to see if it was firmly fixed in its socket, and a heap of yellow dust and finely powdered wood fell into my hand; the cleats fell off of their own accord. The icon was so worm-eaten that if I had knocked it against the stone floor it would have disintegrated into a mass of yellow particles. It was a miracle that it had not done so before. I wondered for a long time

whether to take it or not; I was put off by its condition and by the coarse, rustic daubing of its surface.

Having been told not to arouse the curiosity of the inhabitants, I carried home the icons I had chosen late at night. I could hear the rain rustling on the ancient lime-trees, which were invisible against the cloudy sky.

Some of the icons proved of little interest; others promised to reveal their antique beauty under the restorer's hand. As for the worm-eaten one, I left it alone for a long time, not because I was afraid to touch it but because I did not expect it to have any merit. Finally, at dawn one day, when I was tired out by the work of cleaning a large icon, I decided to experiment on this one. I cut out a square of flannel, soaked it in a strong solution, placed it on the icon under a glass slab, and went back to the large icon. I had found an interesting section of the latter, and became so absorbed in it that I forgot about my 'compress'. It might have eaten through to the panel and ruined whatever painting there was, but at the moment of remembering it I was not especially worried.

Under the compress, the tinsel ornamentation and the black surface had swollen up and become diluted to a thin consistency. I brushed the cotton wool over it, and it came off as easily as the skin from boiling milk. The moment it did so, I was dazzled by a vision of deepest blue and pure, rich vermilion.

The panel had to be treated with various liquids and then set in a wooden frame. That icon is now the finest in my collection; but it is dear to me not because it is the best, but because it comes from my own village. It represents the Saviour among the Heavenly Powers: the rhombus and outer square are dark red, the oval is a deep vivid blue. The Saviour's garment is a dark cherry colour with a pattern of gold thread, and his face, hands and feet are in a noble ochre. The icon was in

fact the centre-piece of a large Deesis tier from the iconostasis in the old wooden church. Looking at the beauty and brightness of this icon we can imagine what the whole tier was like, and if we visualise this in all its red, blue and yellow radiance we can form a picture of the interior of the old church in the fifteenth, sixteenth and seventeenth centuries, before the practice grew up of partially covering the icons with metal plaques.

Nowadays, whenever I come to the collective farm depot to buy meat or something of that sort, I look at the spot where my icon used to hang from the middle of the last century onwards – a marvel of Russian art which survived all these years but was only saved by a miracle from sharing the fate of its neighbours.

*

As the reader will understand, I could relate many more of my experiences as a collector, but it is time to stop. If I have given him some idea of the triumphs and difficulties of this type of collection, I am content.

Looking back at the early part of these notes, I recall what Pavel Korin said to me: 'It's not a simple matter, and it takes a lot of money. My collection was quite different from this at the start, but afterwards I began to select. For five bad icons you can get one average one, and for three average, one good one. For three good ones you can get one first-class specimen, a work of astounding beauty. It has taken me forty years to build up this collection of splendid icons.'

As I finish writing these notes, it is over six years since I started my own collection. It still contains all the items that I have ever acquired, and I fear that I shall find it hard to take Pavel's advice, wise and experienced though he was. How could I bring myself to part with an icon, however 'average', that I treasure not only for its artistry and feeling but because it

reminds me of standing in the rain on country roads, of the collective-farm foreman I made friends with and the old woman I begged the icon from, and above all the joy with which I brought it home!

I can well understand the viewpoint of a Moscow collector of former times, A. P. Bakhrushin, who wrote an interesting book on collecting. The following passage from it may form a fitting close to these notes of mine:

He had built up a large and first-class library, which he never insured and which he kept in an old wooden villa that might have gone up in flames any day . . . I myself do not insure either my books or my collection. I look at the matter in this way: if a man is a collector he puts his whole soul into his collection, and if, which God forbid, it should be destroyed by fire, then no insurance money will bring it back or fill the gap in his life and comfort his bereaved heart. And if he starts all over again and collects the same books, bronzes, pictures, coins or whatever it is, they will not really be the same. His collection may in time be as good as the one he lost; but the first one, which taught him how to collect, on which he spent the best years of his life and which was fraught with so many memories – for each book and each object has its own history, and, however big the collection grows, its owner will recall lovingly how he came to possess this or that particular rarity – the first collection, I say, will be no more, and all the money in the world will not bring it back again.